Samuel Palmer's Italian Honeymoon

EDWARD MALINS

Samuel Palmer's
Italian Honeymoon

London
OXFORD UNIVERSITY PRESS
NEW YORK TORONTO
1968

Oxford University Press, Ely House, London W. 1

GLASGOW NEW YORK TORONTO MELBOURNE WELLINGTON
CAPE TOWN SALISBURY IBADAN NAIROBI LUSAKA ADDIS ABABA
BOMBAY CALCUTTA MADRAS KARACHI LAHORE DACCA
KUALA LUMPUR HONG KONG TOKYO

Printed in Great Britain
by W & J Mackay & Co Ltd, Chatham

For Meta

Preface

THE recent reappearance of all of Samuel and Hannah Palmers' letters written in 1838–9 from Italy on their honeymoon to her father and mother, Mr. and Mrs. John Linnell, was of much interest. Any letters or diaries revealing how artists have lived and thought are obviously essential to an evaluation of their complete work, and many letters of artists in the early nineteenth century have been lost or destroyed. Accompanying these letters, also in the possession of Miss Joan Linnell Ivimy, were the comments of A. H. Palmer, their son, who had copied out the entire correspondence. With the aid of this MS., some of it written as late as 1929, A. H. Palmer had intended to publish a biography of his father, but he died before he had finished. Had it been published it would have shown a very different picture of events from the one which he had drawn earlier in his *Life and Letters of Samuel Palmer*, 1892. Latterly, A. H. Palmer's attitude to everyone who came into contact with his father, and especially the Linnell family, became so distorted that it lost all semblance of objective judgement. He, who was so close to it all, might have been helpful in elucidating certain personal features of his maternal grandfather, John Linnell; yet he drowns the truth in a dark and turbulent sea of hatred and abuse. From the Linnell side of the correspondence, which has been known about and quoted from for some years, certain conclusions have been drawn, including the chief one that John Linnell was a difficult man to deal with. He certainly was no easy father-in-law for Palmer, as their relationship had started as teacher to pupil. But he was not the villain that A. H. Palmer and later writers copying him would have us believe. The Palmers' letters never seem to have been investigated simultaneously with the Linnell replies, except possibly by A. T. Story in his *Life of John Linnell*, 1894, and later by A. H. Palmer himself. So it has previously been impossible to reach a sound assessment by an examination of the give-and-take of both sides in

the complete series. A. H. Palmer's comments reveal him as having a rodent jealousy which gnawed at all who were successful in material terms as painters compared with his father, whose life he miscalled 'a dreadful tragedy' on account of his comparative poverty.

Aesthetic and painterly discussions in the letters between John Linnell and Palmer disclose many of the influences on both of them. Palmer, like Blake, was quickened by literary inspiration, being well read in *The Republic* and later neo-platonists, in Virgil, Shakespeare, and Milton; while in Italy it is the pastoral influences in Virgil, as well as the neo-platonist background to the Italian Renaissance, which absorb him. Even in his earlier Shoreham period as well as quoting from the Psalms or Milton on the back of the mounts to his water-colours, he often makes indirect references to literature in the subject-matter of the drawings. A typical example is his 'Valley thick with Corn' (1825), which had a quotation from Psalm LXV on the original mount. There is also John Bunyan's Christian, the archetype for the journey to the transcendental, attired in the new coat given him by his Lord, reading while he reclines in his 'arbour' half-way up the Hill Difficulty, the gate and the two ways being clearly evident in the background. It is not suprising that Palmer, so strongly influenced by the spirituality of William Blake, does not later fit into the successful Victorian genre scene typified by such paintings as William Collins's 'Happy as a King' or Mulready's 'Toy Seller'. This influence of Blake, as well as of Dante and Milton, became engrained in Palmer's mind, but touched only the surface of Linnell's thought, and enabled him to adapt to the materialism of the Victorian world; unlike Palmer, who found it insupportable. The letters from Italy disclose these differences as well as many other values of the time.

Palmer's absorbing interest in Italy was consistently centred on the treatment of light in the landscapes of Giorgione and Titian, with the idyllic landscapes of Claude and the neo-platonist background of Michelangelo and Raphael. To the end of his life these three dominant themes remain with him, becoming the basis of his later work in which he was brilliantly successful—his thirteen etchings engraved from 1851 onwards—which have perhaps been neglected in the admiration for his earlier Shoreham painting.

Future generations may even come to appreciate his later water-colours, still often inspired by Virgilian influences; though, as Blake said of Fuseli's drawings, it may take a century 'before the world realizes their worth'. Palmer's two Italian years reveal a consistency in his development, and provide an unbroken link between his earlier and later work. He never wavered in his belief in idyllic landscape as having a spiritual signification.

In these letters, the Palmers' poverty in Italy is revealed simply as a lack of patronage, and this continues throughout his life. It was partly because he did not paint those topographical landscapes which were popular, and partly the result of an abruptness of manner with a lack of light conversation which was unattractive to possible patrons. Those with a deeply serious outlook on life commonly suffer in this way. Also it has been possible after examination of this correspondence to correct misconceptions with regard to Hannah Palmer. She was anything but a 'puritan', as has been stated, but a vivacious little woman and a capable artist who was of much value in her husband's life and work. Apart from all these considerations, it is pleasant to read of the happiness of Samuel and Hannah Palmer on their honeymoon—a happiness which they always remembered, despite a deterioration in the relationship with John Linnell.

I have chosen to present these letters not simply as a travelogue nor as a fully edited text; so the influences which make this journey important in Palmer's development cover a wide field. Therefore I have received much help from a wide variety of sources, for which I am most grateful. Above all, I should like to thank Miss Joan Linnell Ivimy for her continual help with regard to Linnell family history, and for allowing the MSS. in her possession to be inspected and catalogued, sometimes at personal inconvenience. Without her inestimable help and that of Dr. Francis Warner, in realizing the possibilities in the MSS. and in arranging the arduous task of cataloguing, the work might never have been begun or finished. Likewise I am indebted to Mr. Anthony Richmond for his aid with regard to the Richmond MSS., and for his liberal outlay of time given to me. To Mrs. Donalda Palmer of Vancouver I am also grateful for permission to quote from the Palmer correspondence. I should especially like to thank many friends who are pursuing

research in similar fields, particularly Mr. Carlos Peacock, who has been most generous in sharing scholarly information, and Mr. Geoffrey Cumberlege, Mr. Peter Fitzgerald, Dr. T. R. Henn, Mr. Philip James, Professor Walter Kaiser, Mr. Raymond Lister, and Miss Kathleen Raine for their invaluable assistance in their own specialist studies. Mr. Ian Lowe, of the Department of Western Art, the Ashmolean Museum, Oxford, has put much of his time and knowledge at my disposal; similarly I am grateful for permission to reproduce pictures, and for learned counsel from Mr. E. A. S. Barnard; Mr. Cannon Brookes, Keeper of the City Art Gallery, Birmingham; Mr. Frank Constantine, Director of Sheffield Art Galleries; Mr. Michael Jaffé; Miss Gillian Kyles; Mr. Paul Mellon; Mr. R. L. Ormond, Assistant Keeper of the National Portrait Gallery; Mr. Kerrison Preston; Miss E. Shapland of the National Art Collections Fund; Mr. Dudley Snelgrove of the Paul Mellon Foundation for British Art; and Mr. A. Wilson of the City Art Gallery, Bristol. Moreover, I am indebted to friends for their aid in reading the typescript, in part or whole, and for giving advice which has shaped the book or enriched the detail, especially to Mr. and Mrs. Rupert Gleadow, Dr. John Malins, and Mr. and Mrs. Robin Tanner. Lastly I should like to thank the Keeper of Prints and Drawings, the British Museum; the Deputy Keeper of the Department of Paintings, the Victoria and Albert Museum; the Director of the Whitworth Art Gallery, Manchester; the Keeper of Art, Bolton Museum and Art Gallery, for permission either to see or reproduce pictures; and to Miss Rhoda Baxter, Librarian of the Vancouver Public Library; Mr. F. A. Boydell of the John Linnell Trust; Mr. John Farrell, Assistant Librarian, Bristol University Library; Mr. Basil Giles; Dr. Frank Hardie; Mrs. Enid Linnell; Mr. Jeremy Maas; the Reverend Kenneth Pillar, Warden of Lee Abbey; and Sir Arthur Richmond for their help in several valuable ways; to Mr. Alan Hamilton for his excellent photographs and to Dr. J. Vincent Hall for allowing them to be taken at Linnell House, 38 Porchester Terrace; and finally, to my wife for her most salient criticism of the text throughout.

November 1967 E.M.

Contents

Plates

MAP

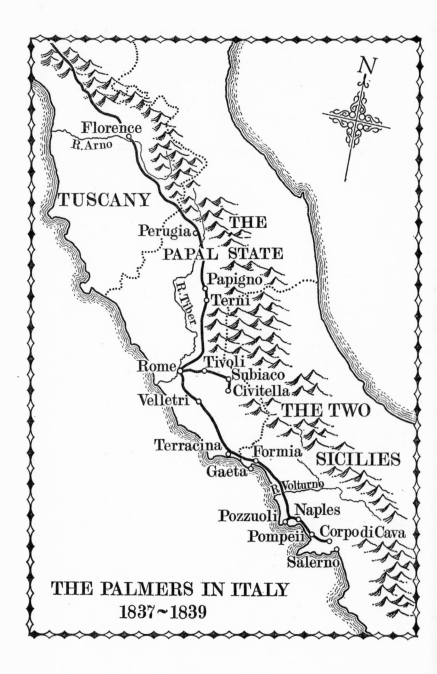

THE PALMERS IN ITALY
1837~1839

John Linnell and Samuel Palmer

Canto dal mio buon popol non inteso
E'l bel Tamigi cangio col bel Arno.
MILTON, *Italian Poems*, Sonnet III

BEFORE trying to estimate the fiery influence on Samuel Palmer of John Linnell, his 'good angel from heaven', it is as well to trace briefly the outlines of their lives until they met. Thus, their relationship, which was of long standing by the start of the Italian tour, will be better understood.

On 27 January 1805, Martha, the wife of Thomas Palmer, a bookseller, gave birth to their eldest child, Samuel, in a house in an unfinished square off the Old Kent Road at Newington. They were amiable and easy-going parents, moderately well off, as her father, William Giles, was a banker. Samuel grew up attended by Mary Ward, an affectionate and literary nurse, who read him parts of the Bible and *Paradise Lost* from an early age. Being somewhat puny and fragile, he had no regular schooling, but read much from his father's books. A love of the Bible, sound Latin and the rudiments of Greek were given him by his father; and, above all, a love of the country-side, which was then not far off, the fields of Dulwich being within walking distance. A sketch of a windmill—perhaps the one on Dulwich Common drawn by David Cox[1]—done by Palmer when he was seven, has the date and his mother's writing on the back. When he was thirteen his beloved mother died; but not before she

[1] *A Treatise on Landscape Painting and Effect in Watercolours*, by David Cox, London, 1813, Plate XVII.

had given him encouragement and seen him apprenticed to a drawing-master, a certain Mr. Wate, who for a few years had been showing landscapes at the British Institution. Her father had been patron to artists, and had had Thomas Stothard and Thomas Uwins, the Royal Academicians, as friends, so she had grown up knowing of artists and their way of life. She was said to have been the model for Stothard's drawing of a pensive and demure girl seated in her rustic arbour, engraved as a frontispiece to a book entitled *The Refuge* written by her father. This little octavo volume is a series of letters addressed to a young lady called Lavinia who is the orphaned daughter of 'one of the first families in London'. The poor girl on reading it must have been obsessed with sin and guilt, despite her obviously harmless pursuits. In his previous work, *The Guide to domestic Happiness*, William Giles at least had given another imaginary young lady some practical as well as spiritual advice, fulminating on the 'luxury, the dissipation, debauchery and extravagance which disgrace the man of business' (he was one himself, so doubtless had inside knowledge), apart from the 'universal depravity of human nature'. As Samuel Palmer matured, this Evangelical influence from his grandfather widened into a happier attitude to life, if, indeed it ever much influenced him. William Giles's family, especially John and Samuel, the lifelong friends of Palmer, possessed a gaiety, untroubled by a sense of deep sin, and an interest in the arts which was their salvation.

So great was Palmer's talent that on his fourteenth birthday he received a letter from the British Institution announcing the sale of his first picture, 'A Bridge Scene, Composition', for seven guineas. Then his ambitious drawing-master, Mr. Wate, encouraged him to send three water-colours to the Royal Academy, and all three were accepted. By then his father, with Samuel and William, his two children, and their nurse as housekeeper, had moved to Broad Street, Golden Square, Soho, only a few houses away from John Varley, the greatest teacher at the beginning of the century. Through William Giles, his maternal grandfather, Palmer met artists, and it was not long before the aged Thomas Stothard introduced him to more; among these perhaps was John Linnell, who had admired at Varley's some of his sepia landscapes. So in

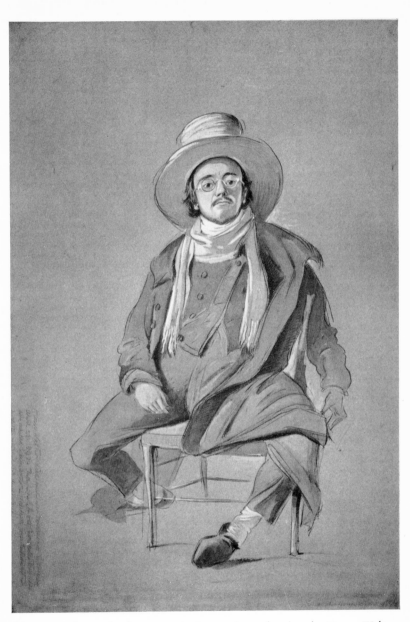

1. Portrait of Samuel Palmer, water-colour and pen drawing, by Henry Walter,
1835. *The Print Room, British Museum*

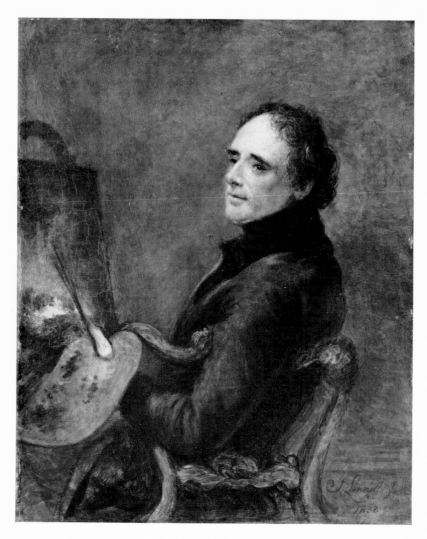

2. Self-portrait in oils, by John Linnell, 1838. *Michael Jaffé Collection*

September 1822 began the tutor-student friendship between the seventeen-year-old Samuel Palmer and Linnell, the up-and-coming portrait painter, who had established himself with his wife and children in December 1818 at Cirencester Place, Fitzroy Square, as well as at Hope Cottage, Hampstead.

Linnell's father, a London carver, gilder and picture-framer-cum-dealer, had realized soon, like Palmer's, that his son had talent. But needing money, he had set him at a youthful age to making pencil drawings of Morland's paintings, which were then popular and saleable. Fortunately, in 1804, at the age of twelve, having had no schooling, he was spotted sketching at Christie's sale-room by William Varley, youngest brother of John Varley, then at the height of his fame as a drawing-master and water-colourist. In a short time, encouraged by the urgent wish of young Linnell, John Varley had persuaded Linnell's father to let the boy come as his student at No. 5 Broad Street, Golden Square. These were the formative years, where under the tutelage of Varley, who was genial and, though easy-going, an excellent teacher, John Linnell's skill as a painter and draughtsman became evident. In the summer, with William Hunt, a fellow student, he visited Varley's house at Twickenham, where he was able to paint from nature, and soon began to show his aston-ishing visual memory for shapes, colours, and landscapes. During this time his deepest friendship was with another student, the painter William Mulready, who became an R.A. in 1816. There was six years' difference between them; when they first met Linnell being only fourteen, but Mulready already married. They became inseparable, the pair often being seen together—the burly Mulready and the little, stocky, and determined Linnell. At John Varley's he made other valuable connections; the aged P.R.A., Benjamin West, took much interest in him and invited him regularly twice a week to bring his work, to discuss and watch him painting. In November 1805, still only fourteen years old, he enrolled as a student in the R.A. school at Somerset House, where Fuseli had recently been appointed Keeper. Two years later he had two landscapes accepted for the R.A. Exhibition, and by 1810 he had shown his versatility by gaining a prize for modelling, in competition with sculptors, as well as one for painting. In fact, he was the student-of-the-year.

Soon patrons started to buy his work which they had seen at the British Institution or the R.A.; Sir Thomas Baring, the banker and amateur artist, in 1811 bought his 'Quoit Players' for seventy-five guineas—a considerable sum for the work of one so young. This picture is typical of his early style—Dutch genre in feeling: quoit players in front of some cottages, with others looking on, and a wood and distant landscape scene in the distance.

Also at Varley's he met many of the literary men of the time, among others William Godwin and Shelley. From them it is possible to trace Linnell's lifelong radical and republican philosophy, and his hatred of priestly hierarchies, no doubt engendered by Leigh Hunt's *Examiner* and Godwin's *Essays*. At about this time he was introduced by Cornelius Varley to John Martin, a Baptist minister of determined character and ideas. In 1812 Linnell entered the sect; but was obviously never completely in sympathy with all their doctrines, for when he wished to marry Mary Palmer (no relation to Samuel), the daughter of one of them, he did not resort to a Baptist ceremony, but took her off to Edinburgh for a civil marriage.

On returning, they settled down in Rathbone Place, off Oxford Street, and there, with the help of John Varley and Mulready, he slowly obtained commissions for portraits from rich patrons. All through his life he was a craftsman who seemed able to turn his hand to anything, and soon his ability in executing portrait miniatures on ivories was gaining him more patronage.

While living there he was introduced by the younger George Cumberland of Bristol to William Blake; and he noted in his *Journal*[1] that he took a portrait to Blake to be engraved on 24 June 1818. Blake was then sixty-four and somewhat embittered by his failure to secure recognition, despite his many works: among others, illustrations to 'The Songs of Innocence' and 'The Songs of Experience', to Young's 'Night Thoughts', to Milton's 'Comus' and 'Paradise Lost' and to 'Jerusalem'. Until his death in August 1827, Linnell befriended Blake continually, introducing him to Coleridge and Lamb, and in a practical way to fellow artists such as John Varley, Sir Thomas Lawrence, James Ward, and Thomas Stothard. Among these the friendship with Varley was rewarding, for the

[1] Ivimy MSS.

turn of Varley's mind, as Gilchrist says, cherishing 'a passion for the marvellous' and loving 'to have his senses contradicted', combined with a most amiable temperament, appealed to Blake, who found him an excellent listener.

When Blake was in want Linnell arranged through Lawrence for a grant of £25 to be given him from the R.A. The next year Linnell paid him £100 for a duplicate set of the *Job* designs and offered him another £100 from the profits by sale. When no profits accrued he gave him £50 for the plates. However much one subsequently dislikes many of Linnell's actions, it is impossible to ignore such figures as these, which were not then negligible sums from an artist in his twenties.[1] During the last three years of Blake's life he commissioned illustrations to *The Divine Comedy*, which almost entirely occupied Blake.

At Varley's in 1824 Linnell introduced Blake to Palmer, to whom he had previously shown Blake's work. Only a few years before, Blake had finished the seventeen wood engravings for an edition of Virgil's *Pastorals*,[2] sponsored by a Dr. Thornton who was the Linnells' family physician. Blake gave Palmer four prints and the tremendous effect of these on him, already steeped in Virgil, is not hard to imagine. Tiny though they are they contain rare visions of landscape, nearly always with not naturalistic figures, with elongated bodies, small heads and aspiring gestures, seemingly reaching out of the world of reality. According to Palmer, these figures had 'intense, soul-evidencing attitude and action, and that elastic, nervous spring which belongs to uncaged immortal spirits'. Palmer's chalk and wash drawing, 'Ruth returning from gleaning', for example, is directly reminiscent in pose of the figure of the shepherd chasing away the wolf from his sheep-folds in Blake's seventh engraving of the series. And although, as Sir Anthony Blunt has pointed out,[3] there is much common treatment of poses and gestures between Fuseli, Stothard, and Blake, there is no doubt of the im-

[1] Sir Geoffrey Keynes, in *Blake Studies* (London, 1949), estimates that Linnell was £120 out of pocket on Blake's death, and had no hope of getting it back.

[2] The section which Blake illustrated was not even a translation of Virgil, but only an *Imitation of the First Eclogue* by Ambrose Philips, in verse which was the worst archaic nonsense, to be used by schoolboys for conversion into Latin. Blake's woodengravings are pearls among this literary debris.

[3] *The Art of William Blake*, Oxford, 1959.

mediate influence of Blake's vivid and bold imaginative quality on
the painting and engraving of Palmer and his friends, George
Richmond and Edward Calvert.

Linnell had settled his family at North Hampstead in 1824, and
to his rooms in Collins' Farm on the Heath Blake would often walk,
accompanied by one of these devoted young men. These evenings
at Hampstead, and visits to galleries, and Blake's trip to Shoreham
left lasting impressions on Palmer, to whom Blake always gave
'sweet encouragement'. Although Blake's theory that the imagin-
ation is weakened or deadened by natural objects, nature not having
the 'outline' which imagination had, may not have been practical
advice to a young painter, yet he gave Palmer a deep spiritual and
philosophic insight which remained with him throughout his life.
Palmer's final etchings, illustrating Virgil and Milton, could never
have been achieved without the influence and encouragement he
had received at this impressionable age. Palmer never succumbed
to Victorian mid-century values and materialism because he had
once been caught in a shaft of sunlit idealism from Blake's mind, an
idealism which, for all its Christian emphasis, was also neo-platonist
in its roots, despite Blake's disavowals. He was also attracted by
Milton, whose concept of Plato's Ideas, preceding Christian thought,
also appealed to him. Brought up to read Spenser, from whom Milton
derived much of his Renaissance thought, Palmer is constantly
occupied with the Platonic doctrine of Ideas in both Spenser and
Milton, expressed in imaginative terms, denying a physical reality.[1]
Blake's spiritual concentration, his nobility, his visions of the soul,
never left Palmer; nor, literally, did prints of Blake's *Virgil* wood-
cuts, the

visions of little dells, and nooks, and corners of Paradise; models of the
exquisitest pitch of intense poetry. I thought of their light and shade,
and looking upon them I found no word to describe it. Intense depth,
solemnity and vivid brilliancy only coldly and partially describe them.
There is in all such a mistic and dreamy glimmer as penetrates and
kindles the inmost soul, and give complete and unreserved delight,
unlike the gaudy daylight of this world. They are like all that wonder-

[1] Although 'The Cave of the Nymphs' is paradoxically a physical reality with its
light and shadows, such opposites, as Yeats saw, can be resolved in the after-life.

ful artist's work the drawing aside of the fleshly curtain, and the glimpse which all the most studious saints and sages have enjoyed, of that rest which remaineth to the people of God.[1]

In Palmer's autobiographical account in *The Portfolio* (1872) he says he was 'forced into the country by illness' to live 'for about seven years at Shoreham, Kent, with my father. . .' Together with the letters from Italy, 1837–9, there is one dated 1824 from Shoreham which has come to light, and which is very typical of Palmer's humour and his critical preferences at the time. It shows Palmer at Shoreham during August and September 1824, thereby dating two Lullingstone drawings which he made for Linnell. More important, it illustrates the tutor-pupil relationship between them. Linnell had evidently told him to observe nature carefully and not to draw from imagination, as did Blake.

> Shoreham Kent.
> Wednesday September. 1824.

My dear Sir

I have to thank you for your very ingenious hieroglyphic; I intend to look up a frame for it; but I think you should come immediately to the hopping for fear of rain or accidents. Here are no swollen racks big with tempests and destruction, besides I thought your cloak defied the wind & your hood the whirlwind. But here are no winds that would hurt a baby—no Eastern blasts atal, nothing but fresh'ning gusts—zephyrs &

> 'The balmy spirits of the *Western* gale'.

I have begun two studies for you on grey paper at Lullingstone—if you make haste you may prevent my spoiling them. I have been doing a head on grey paper life size & tinted, also another sketch of the same person smaller. Have I not been a good boy? I may safely boast that I have not entertain'd a single imaginative thought these six weeks. While I am drawing from Nature, vision seems foolishness to me— the arms of an old rotten tree trunk more curious than the arms of Buonarotti's Moses—Venus de Medicis finer than the 'Night' of Lorenzo's tomb, & Jacob Ruysdaal a sweeter finisher than William Blake. However I dare say it is good to draw from the visible creation

[1] Palmer's Sketchbook for 1825, quoted in *Life and Letters*, pp. 14–15.

because it is a sort of practice & refreshes the mind tired with better things & prevents spoiling them which I have so often done & so bitterly lamented.

So I will seal this foolscap & instantly go forth & make out blades of grass & brick & mortar & new boards & old boards & brown boards & grey boards & rough boards & smooth boards & any boards except *board ministers* with a vengeance. And I confess I am more fascinated with the brawn of M. Angelo's Night or the huge Kemsing Sow than with most exhibitions of clover & beans & parsley & mushrooms and cow dung & the innumerable etceteras of a foreground.

I am glad Clary does well for her sake & more for yours, for a bad servant is a home nuisance. Hoping that by tomorrow night you will be cover'd by the skies of the valley—with best respects to Mrs. Linnell & love to the little ancients I remain

<div style="text-align:center">

Dear Sir
You oblig'd obt Sert.
Samuel Palmer.

</div>

Palmer has been 'a good boy' and followed this advice. Although in art matters he often sought Linnell's help and followed his suggestions, he could not accept Linnell's opinions with regard to politics or religion, being Tory and Church of England as opposed to Linnell's radicalism and unorthodoxy. It is fortunate that in a minor practical matter—the preservation of the letters to and from Italy—Palmer obeyed Linnell's meticulous instructions on how to use gum-water and tissue to preserve them when torn, and how not to fold them more than once. As a result, these letters, on their thin but strong quarto paper, are untorn and legible after 130 years. The form of this relationship was then admirable, but later, after Palmer's marriage to Hannah, Linnell's daughter, it was most difficult for Linnell to adjust sufficiently to translate it satisfactorily into father—son-in-law terms. Linnell was by nature an instructor, so he constantly proffered advice on thought and behaviour, which he expected to be followed. This is the crux of his subsequent difficulties with Palmer.

Much is known of the Shoreham, Kent, period of Palmer's life, which dates from as early as 1824, although he may not have settled there until after March 1827, when his father sold his bookseller's

business. Also well charted is Palmer's progress during those years, his meetings with Blake, and the constant gatherings of the 'Ancients', as his friends were called. Chief among these was George Richmond, a lifelong friend of Palmer's who as a boy knew the Giles family, Palmer's cousins. The son of a miniature painter, and four years younger than Palmer, but equally prodigious, he attended the R.A. school at the age of fourteen. Of those who went in this group to Shoreham he was the only one who was later successful in worldly terms, chiefly as a portrait painter. As a boy of sixteen he had met Blake at the Tathams, his cousins, and it is not surprising that after the meeting he declared he felt like 'walking on air' as if he 'had been talking to the Prophet Isaiah'. In that same year he remembered visiting the Linnells at Hampstead, coming back at night, guided and guarded by a servant with a lantern. Two years later (1827) he walked the twenty miles to the thatched cottage at Shoreham, where the genial old Thomas Palmer made them tea in the early hours of the morning. On 12 August of that year Blake died. A few days later Richmond wrote to Palmer:

<div align="right">Wednesday Even^g</div>

My D^r· Friend

Lest you should not have heard of the death of M^r· Blake I have written this to inform you—He died on Sunday Night at 6 O'clock in a glorious manner. He said He was going to that Country he had all His life wished to see & expressed himself Happy hoping for Salvation through Jesus Christ—Just before he died His Countenance became fair—His eyes Brighten'd and He burst out in singing of the things he saw in Heaven. In truth He Died like a Saint as a person who was standing by Him observed—He is to be Buryed on Fridayay [*sic*] at 12 in morn^g—Should you like to go to the Funeral[1]—If you should there there [*sic*] will be Room in the Coach.

<div align="center">Yrs affection^y
G Richmond</div>

Excuse this wretched scrawl

The next year Richmond was in France, where Palmer wrote to him of his hopes for Italy. By now he possessed all the social

[1] Linnell paid for the funeral and the interment in Bunhill Fields burial ground. Palmer did not attend.

qualities which Palmer lacked: a Byronic appearance, but with vivid, kindly eyes, a distinguished courtesy, a brilliant conversation, and an apt memory for people. On his return from France these qualities, combined with talents in portraiture, meant he rarely lacked patrons. At the age of twenty-one, Lord Sidmouth took him into White Lodge, Richmond Park. But he still had little money, giving drawing lessons to eligible young ladies, among whom was Julia, the daughter of Frederick Tatham, an architect. At the beginning of 1831 he asked her father's permission to marry her, but being without sufficient means was refused. Thereupon he borrowed £40 from Palmer, dashed the lady off to Gretna (chaperoned by his brother), where in midwinter they were married. John Linnell, who had also travelled to Scotland to get married, though in less eccentric circumstances, consoled the bride's father, and indeed convinced him that the marriage was not as bad as it seemed to him.

Richmond's early work, such as the tempera painting, 'The Creation of Light', done when he was seventeen, has a superficial resemblance to Blake's work in its choice of colour and textures. But the figure of God in this painting could never have been drawn by William Blake: there is an anatomical heaviness and a ridiculous pose—a middle-aged man flying through the air—quite unlike a Blakean representation of the Deity. Richmond's pen drawing 'David playing to Saul' and his copper engraving 'The Shepherd' also superficially resemble Blake's drawing. But soon his ability in accurate portraiture superseded all else, and his water-colour portrait, R.A. 1833, of the aged William Wilberforce, looking at his two watches to compare the time, made Richmond's reputation. For on Wilberforce's death in the same year the portrait was engraved by Samuel Cousins with world-wide success, selling many thousands of prints. By the middle thirties Richmond was able to get £75 for one of his pictures, and in 1837 had eight portraits in the Royal Academy.

Among others who were members of the group who visited Shoreham and who knew Palmer well were Edward Calvert, a painter and engraver, with whom Palmer went on his Welsh tour in 1836, and Oliver Finch, a painter who had been articled to John

Varley, when aged thirteen, in 1815. Calvert does not concern us with reference to the Italian tour, as he never bothered to write to Palmer during the years in Italy. Finch, though less well known, is relevant to the extent that his reading was similar to Palmer's. At twelve he could repeat much of *Paradise Lost* and *The Faerie Queene* by heart, and was well read in Gray and Thomson. Despite this background, his own poems read like the worst of Robert Bridges, and his few water-colours have little more than a charming delicacy. He died in the 1860s, but not before the tide of Victorian sentiment had drowned him, as it never did Palmer. This sentiment enabled Finch to write a treatise on the Fine Arts in which he declared the purpose of art was to affect the moral and religious feelings of the spectator. For him, Augustus Egg's 'Past and Present' was the touchstone, even perhaps the zenith.

After the Italian tour these friends used to meet once a month at the Edward Calverts in Paddington Green, where they read poetry aloud or talked. The amiability of Richmond, the oddity and humour of Palmer were remembered by Samuel Calvert, a son, and also the fact that Linnell was seldom present.[1] Neither did Linnell consider himself, nor was he considered, perhaps on account of being older, one of the earlier Shoreham group, although he visited the cottage there. By the age of thirty-two he was a man of determined ideas, violent prejudices, untempered by academic training, though disciplined at the R.A. school, and absorbed by a driving passion for work. Indeed, he thought Palmer's 'voluntary secession from artists' at Shoreham might end in the 'withering of art' in his mind, so he suggested he should have some practice at figure drawing at a recognized art school. Palmer ignored this advice. In 1823 he had spent some untutored time in the British Museum drawing antique statues in the Elgin and Towneley collections. Yet he never entered the R.A. schools for regular instruction under Fuseli, as did George Richmond.

The best of Palmer's work from this period is readily accessible. Many have marvelled at his startling vision; while others have acknowledged their debt or traced his influence on post-impressionist and later English painters. His small sepia drawings or water-

[1] Samuel Calvert, *Memoir of Edward Calvert*, London, 1893.

colours of church spires rising from valleys below rounded hills, the knots of harvesters' heads embraced by the corn, the cottages buried in woods, the clouds, fields, and moon-lit landscapes, are collectively one of the most exciting and intense moments in English art. But whether it was vision or waking dream, he never achieved a similar intensity again, except in his final etchings. Early in 1826 Palmer had inherited about £3,000 from his maternal grandfather, and with this money he was enabled to live simply in Shoreham, reading widely, writing verse, and painting that luxuriant valley as he saw it, and not as he thought patrons would like to see it. This made possible his unique output during this period.

The first letter from Palmer to Linnell to be quoted in A. H. Palmer's *Life and Letters of Samuel Palmer* (1892) is dated 21 December 1828. Apart from the major omission of a paragraph, A. H. Palmer here reveals in a minor way his prudery, and his inaccuracy in quoting. The first by the simple omission of the word 'chamber' before 'pot'; the second by misquotation in a description by Samuel Palmer of a head being 'laboriously muzzled—the least perfect object in the piece, with a careful avoidance of all shape, roundness and outline'. The word 'muzzled' is a nonsensical misreading for 'muzzed', meaning to make muzzy. But the omission of a whole section of the penultimate paragraph is of greater import, although equally true to A. H. Palmer's unscholarly attitude toward the presentation of the truth. In his absurd attempt to create a perfect image of his father, which doubtless caused him to burn Samuel Palmer's notebooks later, he has concealed Palmer's state of mind at Shoreham at this time, which Linnell so rightly sensed. Palmer writes in this letter, after a discussion of the merits of Nature and Art:

To one part of nature I most devoutly subscribe, as perfect beyond compare: I mean the Ladies' eyes, 'The vermil-tinctured cheek— Love daring eyes and tresses like the morn'. O! that I had a pair of such to be my 'Star of Arcady & Tyrian cynosure': a nice tight armful of a spirited young lady, a hearty lover, who would read to me when my eyes were tired, soothe me if vexed, enliven me when sullen; patch my old clothes, & Lie on a mattress, for I understand a feather bed costs 14 guineas, and therefore is not my lot. Also a little

thatch'd parsonage & a little, quiet, simple evangelical flock in a primitive village where none of the King-choppers had set up business, 'The good old Puritans, those Saints' as *Mister Poet Greene* calls them. By the by, how could the King of Arragon in making his exceptions to life's vanity,[1] forget to crown the 'Old wood to burn', the 'Old wine to drink', the 'Old books to read', & the 'Old friends to converse with', with the *Young Wife* to kiss and be kiss'd by; on whose breast to lay a head aching with study, into whose heart to pour our joys, doubled by imparting; in whose love to forget all sorrows and disquietudes? You *have* such a wife—I, only in feeble imagination; but in this instance Give me *Natural* Fact, say I, and care not how speedily.

He has to wait another nine years for the dream to come true, and then it is with Hannah Linnell, whose perfect miniature, done by Linnell, he remarks on in this same letter, hoping, as he says, that the beautiful living models—Hannah, her sister Lizzy, and brother John—will some day themselves be poets or intellectual artists.

The same nine years pass before his wish to go to Italy is fulfilled. Even in December 1828 he was asking Linnell how it might be done, especially as George Richmond had estimated that two might stay in Rome for six months for £90 between them. Evidently Richmond, in France, was planning to cross over the Mt. Cenis pass into Italy, for on 17 August 1828, in a hitherto unpublished letter[2] Palmer wrote to John Linnell from Shoreham advising him first of the easiest route from London to Shoreham, in order to avoid being jolted in a springless cart from *The Tiger's Head* just outside Bromley. Then he mentioned Richmond's intention to go to Italy, commenting on what might be Richmond's reactions to Catholic Church ceremonies. In this Palmer shows the adamantine foundation of his love for the Church of England to which he was later to introduce Hannah Linnell. And this allegiance was finally to estrange him from John Linnell. Their differences in religious opinions begin to show long before the Italian tour, as indeed do their different political sympathies. But Palmer, despite his dislike of Romish practices, with an extraordinary foresight, similar to Gladstone's,

[1] Robert Greene, *The Comical History of Alphonsus, King of Arragon*, 1599.
[2] Ivimy MSS.

realized that the unity of the Church was paramount. Linnell with a narrow dogmatism and hatred of all Church discipline could never have achieved Palmer's breadth of vision, even though Palmer here obscures this in purple rhetoric. The later letters, from Italy, show this cleft in their thought had widened.

If Mr. Richmond crosses Mount Cenis I am afraid I shall envy him sadly except in this, that when drawn by the vesper bell along the twilight valleys he enters the holy gate just as the organ strikes up, & listens to such heavenly voices in trine or solo, such tremulous breathings of symphonies swelling & relapsing with imperceptible gradations, such angelic dialogues of the two quires answering each other, such consummations of enraptur'd chorus, such lofty fugues, such loud hosannas & Alleluias as many seem even to hallow the sacredness of dusky aisles & cloisters & shrines & pictur'd chapels. When he sees and hears such delicacies, when he follows the processions of the dead or hears the organ waked at midnight—who knows but he may fall down & worship *the Beast*, for so we must in this age approve our saintship, by such low abuse of the only church (tho' alas how much corrupted, the frail and erring yet undivided spouse of Christ) the only church which Christ had upon earth from His ascension to the times of the reformers; tho' I consider not the reformed episcopal churches, emancipated as they are from popish usurpation, sophistry and will worship, to be abruptions from the old Catholic church, but members of her body reflourishing in more primitive vigour & health & youth, & I am not without *some* hope that the old trunk may shed its leprosy, the pope doff his insolent crown of universal bishoprick, & so at last, before Christ's second coming we may be led by the healing and uniting sanctification of the blessed Spirit to be indeed *one* happy fold under *one* Shepherd Jesus Christ the Righteous, by the merit of whose blood hoping we may all stand acquitted at his dreadful advent.

　　　　　　　　　I remain my dear Sir your oblig'd affectionate
　　　　　　　　　　　　　　　　　　　　　S. Palmer.

P.S. Pray present my best respects to Mrs. Linnell & love to Anny, Lizzy, Johnny, Jamie, Willy.[1]

In the next month, writing to George Richmond, himself at

[1] Letter dated 17 August 1828.

Calais, he advises him what to do should he go on to Italy. It is a letter of over 6,000 words and although much of it is rhetorical and hypothetical, it again reveals Palmer's own wish to visit Italy. To copy

One or two pictures elaborately in colours . . . by making small drawings for engravings . . . to give my country a true version of the divine St. George of Donatello (at Florence): the thought of bringing home a true & lively transcript of those intense lineaments, and of only a few other such works, would, if I had extra money, surprise you with a waking vision of me and my round spectacles some evening at Calais, ready, with canvas jacket & trousers, club and knapsack, to start next morning for the South . . . I should go thro' as many great & ancient cities as I could, & visit as many Cathedrals & convents, for, by continually asking at every church & monastery after pictures, you may light on one or two, shrined up in the recessed twilight of some oratory, or cloister, worth the whole journey.

But after this follows a passage of the letter which is in a different tone: 'Mr. Linnell tells me that by making studies of the Shoreham scenery I could get a thousand a year directly. Tho' I am making studies for Mr. Linnell, I will, God help me, never be a naturalist by profession.'

By this he means one who goes no further than observing nature, including topographical drawing, as opposed to imaginative 'grand art' similar to Blake's. 'The former', he writes, 'we may liken to an easy, charming colloquy of intellectual friends; the latter is "Imperial Tragedy". *That* is graceful humanity; *this* is Plato's vision'; for although nature must be studied and is sometimes able to 'pour into the spirirual eye the radiance of Heaven', it is 'but the prelude to the drama'. Linnell's 'glorious round clouds' were an example to Palmer of how the 'elements of nature may be transmuted into the pure gold of art'. Palmer never made a thousand a year from his Shoreham paintings, but he was on his way to becoming a 'naturalist' when the work of his subsequent Welsh tours is compared with the exultancy of his Shoreham vision.

Replying from Calais in 1828 to Palmer's long letter, Richmond congratulated him on his 'inflexibility about the Figure, for though

it is certain', he wrote, '*you will not* any more than Mr. Blake get a thousand a year by it [painting], yet you will have what he had, a contentment in your own mind such as gold cannot purchase—or flimsy praise procure. Mr. Linnell is an extraordinary man, but he is not a Mr. Blake.' Wise yet ironic words, for Richmond himself was then in poverty; yet ten years later he was earning £1,000 a year.

Palmer's last letter from Shoreham is dated October 1834, and in that year he bought a small house in Grove Street, Paddington, near the Calverts, and the Linnells in Bayswater. Evidently he used this for teaching, and he listed it on the back of his pictures sent to the R.A. In the summer of that year and the two succeeding ones he went on sketching tours in Devonshire and North Wales, being accompanied by Edward Calvert on the last one. While in Wales in August 1836 he met Henry Crabb Robinson, the diarist, who accompanied him to certain waterfalls in the Beddgelert district, admiring his work, and subsequently meeting him in London to buy a drawing. Crabb Robinson also knew Blake well, and compared him with Linnell, whom he thought was a man of 'worldly wisdom'. Palmer, understanding the insinuation, replied, 'only *defensively*', adding that Linnell's conduct to Blake had been generous. But Robinson, who also knew Linnell, thought otherwise.

Palmer's work on these tours, for example his water-colour of the fig tree and cottage at Tintern, in its delicacy and tonal quietness much resembles some of his work in Italy. The exciting distortions of the planes, and the rich full textures of the Shoreham painting have ceased; although the fascination of the sharp alterations of light and dark at twilight, or when the light is low in the sky, continue unabated. His output in these years is small, his life not being well documented on account of the destruction by his son of those invaluable clasped memorandum-books in which he wrote quotations from his favourite poems and drew in black and white.[1] His loneliness increased as his friends got married, and in January 1837 his dear nurse and housekeeper, Mary Ward, died. One of her

[1] He evidently visited Wales in the summer of 1837 also, for Mr. Geoffrey Cumberlege has a drawing inscribed 'On the r. Machawy, 5 July, 1838—abt a mile below Craig, pwldu—& nr its confluence with the Wye, Radnors.'

last acts was to give him her two volumes of Jacob Tonson's edition of the *Poems of Milton*, from which she had read to him when a child. His grief was great, for she had taken the place of his mother and had sowed the seeds of his love of Milton. At times his spirits haunted 'the caves of melancholy' or were bound in a dark dungeon.

In contrast, Linnell, by 1829, had saved sufficient to build a splendid house in Porchester Terrace, Bayswater (Plate 3) and thither Palmer often walked from Grove Street. For twelve years, since Blake's visits to Hampstead, when Hannah had sat on the poet's knee while he told her stories, or Mrs. Linnell played the piano and sang, Palmer had been visiting them, until he had become almost one of the family—so much so that despite their religious persuasions, the Linnells had allowed him to take Hannah and her younger sister, Elizabeth, to Church of England services locally and at St. Paul's Cathedral.

Despite lack of money, part of his legacy being spent in buying houses at Shoreham, Palmer was evidently welcomed in the Linnell family. In 1837, Samuel was thirty-two, and Hannah nineteen. They had much in common: appreciation of music and literary tastes, skill in drawing, Protestant views, a love of the countryside, and a merry humour. She was a courageous and vivacious hard worker, nursemaiding her younger brothers and sisters and having little time or inclination for social life. But having been brought up among artists, she had come to regard art as the finest profession, and she showed talent in her copies of the old masters as well as in her own drawing. They became engaged and he asked Linnell's permission to marry her. The details of the Linnells' subsequent reactions are based on letters of Mrs. Richmond, and on notes by A. H. Palmer. It is difficult to find the truth. In 1892 A. H. Palmer had written in *The Life and Letters*, that 'not the least interesting feature in the two years Italian residence was a series of letters to the travellers from Mr. Linnell who wrote to them once a fortnight. It is impossible to read these letters without forming a high opinion of the sound sense, and manly, straight-forward character of the writer.' But by 1929 his opinion had altered, and he wrote that 'much of Linnell's life had already been a pious fraud and the rest was destined to be more so'. And then, 'thus began the making of common cause between the

Bayswater couple to defeat and flout Samuel Palmer if they could not destroy the benefits accruing from the Italian work.'[1]

This volte-face starts, therefore, after A. H. Palmer had been shown the Palmer letters from Italy by the Linnells and after the publication in 1894 of *The Life of John Linnell* by A. T. Story, who was thought by A. H. Palmer to have gilded the Linnell ginger-bread by taking the lustre from his father's image. The whole quarrel between the Linnell and the Palmer families, which lasts through two generations, is biased, muddled, and vituperative; and to get at the truth is made no easier by these notes of A. H. Palmer's coming to light. For although he may finally have been in possession of most of the facts, his hatred for Mr. and Mrs. John Linnell was so intense that it unfairly blackened all their actions and motives. A more recent authority on Samuel Palmer has quoted certain random notes by John Linnell, junior, and says that they 'well serve' to 'round off the character' of Samuel Palmer. They cannot achieve this, as they are either superficial, such as references to Palmer's love of good cooking, or insensitive, as is the observation that 'Samuel Palmer's sentimental state of mind (called by some poetical) leads him to descriptions that are partly fictitious, mixed with human and characterturs [*sic*].' Such comments were not worth noting at length if it was hoped to clarify a situation which had already been bedevilled enough by their respective sons.

A. H. Palmer's comments with reference to Mrs. Linnell were so defamatory about her relationship with Hannah—who was very fond of her—that they lose all value. For example, 'Mrs. Linnell's stupidity, obstinacy and selfishness', and 'She cared little or nothing for her children's welfare and happiness or even health, but was completely absorbed in her own. . . Of all the instances of the intercourse of Parents, Children which I have ever known personally, Nature spoke out least in the case of the Linnells'; and 'the concentrated spite with which her mother viewed her engagement and the unutterable selfishness of that woman's attitude during the whole of the Italian tour'.[1] These and many other examples of A. H. Palmer's engrained bitterness were written because he came to the conclusion that John Linnell, a rich and successful portrait painter,

[1] Ivimy MSS.

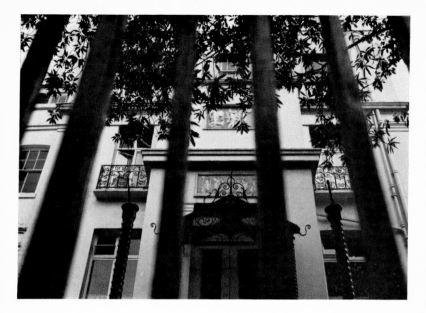

3. Linnell House, 38 Porchester Terrace, Bayswater. (*a*) Exterior, 1967.

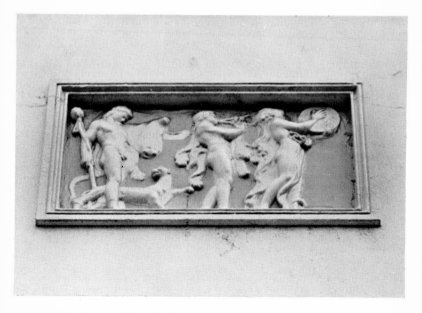

3. (*b*) Detail of panel of bacchanale above front door. *Photographs by Alan Hamilton*

4. (*a*) 'Dramatis Personae at the Eating House', pen drawing, by Samuel Palmer in letter to John Linnell, 23 January 1838

4. (*b*) 'Light and shade of figures in landscape', pen drawing, by John Linnell, in letter to Hannah Palmer, 23 December 1838

had never helped his son-in-law, Samuel Palmer, financially or in any other way from the moment he married Hannah, his daughter. Only by a careful examination of the thoughts and actions of Palmer and Linnell can one approximate to the truth. But one of the blackest actions in the history of art must be the destruction by A. H. Palmer of twenty of his father's sketch-books including some from the Italian tour, because he thought they were 'neither sufficiently masculine nor sufficiently reticent'. Maybe this was true. Samuel Palmer admitted he could drop to the depth of melancholy or rise to the heights of exultancy very quickly, and these mercurial changes show in his letters. But no such revelations should ever have been destroyed, for more than anything they would have served to illustrate the difficulties of Palmer during these years, and the reasons for his painting undergoing such changes.

Palmer's lack of social adroitness, of ability in superficial verbal insincerities with rich patrons was a handicap to him. He looked odd, and moved awkwardly: a bespectacled man in an ill-fitting frock coat with pockets bulging with artist's materials. In October 1837 an official at the *mairie*, Calais, described him on his passport as '*Agé de 32 ans, taille un mètre 73 centimètres, cheveux châtain-clair, sourcils—[illegible], front haut, yeux bleus, nez fort, bouche moyenne, barbe châtain;*[1] *menton rond, visage ovale, teint coloré.*' Although 'average mouth' tells us little, the high forehead,[2] strong nose, auburn hair, combined with a red, round face add up to a striking picture. A. H. Palmer states his father was about five feet five inches in height, so the French official evidently measured him accurately.

Sometimes Palmer affected an outrageous sartorial nonconformity, which is clear in George Richmond's miniature of him in 1830. In this he appears with hair over his shoulders, and in clothes which more resemble the *quattrocento* than those of a nineteenth-century artist. One is apt to forget that the eccentric-looking artist, as personified by Van Gogh or Gauguin, was yet to become acceptable. In any case, this miniature strikingly contrasts with George Richmond's self-portrait miniature of the same date. Here we see a sensitive, handsome young professional artist, in neat stock

[1] No more than whiskers. He had shaved off his beard.
[2] Remarked upon by Crabb Robinson when he met Palmer in Wales in 1836.

and frock coat, with fashionably dressed hair, contrivedly *négligé*.

Palmer, having obtained Linnell's permission to marry Hannah, said he wished they could go to Italy for their honeymoon. From this moment, according to A. H. Palmer, Mrs. Linnell consistently opposed the scheme, even suggesting that Palmer should go to Italy alone! However, having borrowed £300 from George Richmond,[1] who could then afford to lend it, Samuel was allowed to move forward with his plans to take Hannah to Italy with the Richmonds as a *partie carrée*. In giving his consent to the marriage, Linnell insisted on a civil ceremony. To be married in the Register Office at St. Marylebone on 30 September 1837, to comply with her father's wishes, must have been as embarrassing for Hannah as for Samuel, both being regular churchgoers. Such usages for the Courthouse had only just been established, *The Times* remarking that the whole marriage ceremony could be carried out in these new 'marrying shops' in three minutes. But Hannah and Samuel were not in a position to disregard John Linnell's wishes, if they were to have his essential help and sympathy on the Italian tour.

[1] Samuel Palmer had previously lent Richmond £40 to get married at Gretna Green. John Linnell's *Journal*.

Journey to Italy

Her Coliseum stands: the moonbeams shine
As t'were its natural torches, for divine
Should be the light which streams here, to illume
This long-explored but still exhaustless mine
Of contemplation; and the azure gloom
Of an Italian night, where the deep skies assume
Hues that have no words . . .
 BYRON, *Childe Harold's Pilgrimage*, Canto IV

O N the evening of Tuesday, 3 October 1837,[1] armed with their passport signed by Viscount Palmerston, giving Her Britannic Majesty's injunctions in French, 'Samuel Palmer, Artiste, Peintre Anglais et Madame Son Épouse, voyageant sur le Continent avec leurs domestiques' (none), waved good-bye to the Linnell children over the wall of the Bayswater garden, and drove to Brunswick Wharf, Blackwall, where lay the cross-Channel boats bound for France. S.S. *Lord Melville*, one of the most modern, would depart at 7 a.m. the next day, having received passengers the night before. So while the boat lay in dock, Hannah slept in the top bunk of a cabin with Mrs. Richmond and Tommy, her little boy. The voyage round the Nore, though the sea was calm, was exhausting and tedious, for the engines were noisy, the decks trembled and

[1] The date is erroneously given as 12 October by A. H. Palmer, Introduction to the *Catalogue of an Exhibition of Drawings, Etchings and Woodcuts by Samuel Palmer* . . . Victoria and Albert Museum, 1926. The Palmers wrote from Calais on 4 October; and on 4 October 1838 George Richmond records in his *Diary* (Richmond MSS.) that they had been abroad a year exactly.

were crowded with carriages and baggage. Hannah consistently showed intrepidity and courage in all her future travels, and although she now felt sea-sick off the Foreland, she was sufficiently sprightly to observe with pleasure the ear-rings and unusual dress of the French sailors who hauled the steamer alongside the jetty at Calais at 2.45 p.m. Also she noted the politeness of the Customs officials who, having examined the baggage, packed their belongings again. After four hours' sleep in a hotel room, followed by some mutton-broth soup, she felt refreshed enough to dash off a brief letter to her parents and another to Lizzy, describing the journey thus far. At the end of these she explains that Samuel, in the rush of departure, has left a book on a shelf by the fireplace in the Richmonds' back room, and she asks her parents to arrange for a carrier to call to take it to an address in the Temple. Evidently there was no parcel post at a cheap rate outside London at this date. In a later postscript to the letter she admits to leaving her mother's basket at the Richmonds', but that Samuel has now found the book in his pocket. Such touches show an ingenuous honesty in their correspondence which is continued flawlessly throughout their trip.

The next day, before the diligence left for Paris at one o'clock, they wandered round the town of Calais like any other tourists. Entering the fine church of Notre-Dame—the first continental Catholic church they had been in—they were immediately excited by its rich fullness, as well as by the sincerity of the picturesque poor who knelt at the doors or in the dim recesses. It was not a fashionable church such as they had been used to, with fine ladies in lace peeping over pews for which they had paid, but a refuge for the poor and outcast, with no 'brandy-faced beadle to drive Lazarus from the door and waddle before Dives to the chief seats'.[1] In fact, the market people, with their baskets of fruit on the floor beside them, knelt in prayer at all the side altars, many of which were enriched with carved wood or marble, pictures, and statuary in alabaster and jasper. But the poor, wrote Samuel, were 'the richest

[1] Samuel Palmer to his cousin, Samuel Giles. Pozzuoli (near Naples), 28 October 1838. This letter is dated wrongly by A. H. Palmer, *Life and Letters*, p. 201. The Palmers were back in Rome by 27 October 1838, but his mistake is understandable, as the Linnells did not give him Samuel Palmer's letters until after the publication of this book.

of all decorations'. Then into the sunlight they stepped down to the market in the square, with its profusion of vegetables and fruit.

The journey to Paris in a slow and heavy coach was very tiring, especially as they stopped only twice for about a quarter of an hour each time during the whole journey. Fortunately, the coach, on account of its great weight, unlike an English post-chaise, did not sway or rock inducing sickness which Hannah had often felt when travelling. And the early rising sun, shining over golden woods in the fresh morning air, compensated for the dull terrain between Calais and Paris. Rightly, these 180 miles have never been eulogized by travellers going either by St. Omer, Amiens, and Clermont, or by Boulogne, Abbeville, and Beauvais. The villages, after the lush and lively Shoreham scene, seemed desolate, broken down, and deserted. There was no gleam of 'cottage comfort', no rustic chimneys, no village maidens at the door, no healthy ploughmen, the whole according to Samuel looking as if it had been purged rather than purified by many revolutions. Also they disliked the brutal horsewhipping by the French coachman, in contrast with the quiet mastery of a Mr. Tony Weller.

At last, at midnight, on Friday, 10 October, the Palmers' coach rattled over the *pavé* up to the Hôtel Rossignol, outside which stood sinister sentries. Next morning their spirits were revived by a visit to the Louvre, although Palmer remarked that three-quarters of the pictures did not interest him. As it was dark in the rooms, many were difficult to see, while brilliant sunshine seen through deeply recessed windows meant that he was often looking into the light. Yet he was particularly excited by Veronese's 'Marriage at Cana', that very large easel painting, thirty-two by twenty-two feet, which previous generations have rated so highly. Such are the fluctuations of taste that it is not reproduced among a hundred illustrations in *Art Treasures of the Louvre*, by René Huyghe, Curator-in-Chief of Painting and Drawing of the Louvre (1951). It was commissioned from Veronese by the Convent of S. Giorgio Maggiore in Venice in 1562, and carried off by Napoleon to the Louvre in 1796 (a convenient precedent for Hitler's acquisitiveness in conquered countries). The painting is a tremendous *tour de force*, with multifocal perspective and more than a hundred and

thirty figures in it, some hanging or perching on vantage-points of
the Renaissance buildings to gaze down at the banquet in an open
cortile. Meanwhile servants hasten across a balustraded balcony
which runs across the picture. Below this, at the feast, sit Christ and
His Mother in Renaissance costume. At this ideal banquet certain
figures among the guests are recognizable: the Emperor Charles
V and Vittoria Colonna; Francis I and his Queen; Mary I of
England, looking as severe as ever; and in the foreground a chamber
orchestra of musicians among whom are portraits of Veronese him-
self, Titian, Tintoretto, and Giorgione. At their feet stand two
chained dogs—said by some cynical art critics to be a satire on the
married state. Before painting this picture Veronese had just been
to Rome and had obviously been influenced by the vast canvases of
Guilio Romano, and Parmigianino; the whole picture is flooded
with luminosity and Samuel thought 'it was worth a visit to Paris
to see it'—for its highlights and for the brilliance and vitality of its
colour, glowing as if in midday sunshine. The only other painting
which he mentions was 'the Giorgione', by which he indicated the
Concert Champêtre. That and the Titians—at least a dozen of
them—'made sunshine' in the Stygian gloom of the galleries. There
is a radiance of colour, not used just decoratively, in both the
Titians and the Concert Champêtre. This pastoral music-party
glows in the evening sunshine; a scene of tender gaiety, which has
caught the brief moment when the seated lutanist pauses, fingers
poised above the strings. The women's bodies, especially that of the
standing figure on the left, who gracefully turns to dip her glass jug
into the water, are bathed in sweetness and light.

Virgil's seventh *Eclogue*, the literary derivation of this picture,[1]
was well known to Palmer. The *Eclogues* were reread often by him
from his Shoreham days to the very end of his life. While working
on his own translation of them which he was illustrating, he died.
In this, which was published posthumously, there is his last great
etching, 'Opening the Fold'. At the start of the story in this
Eclogue, 'Daphnis had just sat down by chance beneath a rustling
ilex-tree when Corydon and Thrysis each drove up his flock to the
same place . . . a pair of graceful lads and each as ready as the

[1] Stated by R. Eisler, *New Titles for Old Pictures*, London, 1935.

other to lead off with a song or give an apt response.'[1] Although there is only one water-nymph in the *Eclogue* story, many of the other details are in the picture: the large holm-oak, the flock of goats and sheep, with Meliboeus seeking the 'father of his flock' approaching from the low ground in the middle right distance, 'wanton Mincius' winding through the valley in the far distance, and the two musical shepherds sitting on the gentle slope. As Edgar Wind points out, the divine presences are unclothed, to show they are superior to the mortal clothed musicians.[2] Although Palmer may not have recognized the exact literary inspiration of the Concert Champêtre, yet it added up to a powerful subconscious stimulus when combined with his admiration for Giorgione's methods, and his own love of music. The picture is the quintessence of Virgilian landscape, in which Giorgione has set his passion for music. As Walter Pater says of this: 'life is conceived as a sort of listening'; a happy moment in which the water from the jug held by the woman's jewelled hand might be heard to fall.

The Palmers stayed a week in Paris—longer than they intended —but passport difficulties arose with the police, who represented a regime which was unsure of itself. By 1835, after an attack on Louis Philippe's life, the government had become repressive. All this was undoubtedly reflected in the police measures which Palmer had to endure. He suffered 'slow torture', and if his passport had declared them to be felons they could not have been treated worse. The police, who may have been suspicious of his odd clothes and abrupt manner, refused him a visa for Italy until they knew exactly by what route he intended to visit that country, and asked why a '*passeport provisoire*' had not been obtained at Calais. This was no *liberal* government which took away from travellers at frontiers the pistols which they carried for their own safety—annoying for Samuel, who had followed the advice given in William Brockedon's recently published *Roadbook from London to Naples*: 'For security, the traveller should not be without pistols —detonators are safest and best.' Afterwards he discovered that had he given a few francs to the commissionaire of the inn all would have been quickly settled. This

[1] *Virgil, The Pastoral Poems, The Eclogues*, translated by E. V. Rieu, London, 1949.
[2] *Pagan Mysteries of the Renaissance*, London, 1958, p. 123n.

was an expedient which in his honesty he would not have dreamed of, and he might have had further trouble in the police states of Italy had he not been with George Richmond, who knew about such things as the necessity for the Austrian ambassador's signature for the journey, even though they were not passing through Austria, but merely through Italian states controlled by that country.

But these delays in Paris gave them time to explore the city, 'at the risk of being pushed over or run down' by the traffic (a phrase which has current meaning). So once more they went to the Louvre, where Hannah 'made a little drawing from one of the marbles'. Also they visited many churches, especially St. Eustache, the great Gothic mass overlaid with Renaissance detail, near the Halles. They preferred this church to Notre-Dame; the plan is similar—double aisles and chapels going round both nave and choir. Again they would have seen market women kneeling in prayer, this time in the five vast and high aisles of this splendidly proportioned building. It is this quality of life in the churches upon which Samuel again commented: in one church, for example, there were three weddings and a soldier's funeral being conducted simultaneously at the side altars.

Hannah wrote in ecstatic honeymoon terms to her parents and her sister, Lizzy. The sun shone gloriously as they had walked past the white marble statues, orange trees, and fountains of the Tuileries gardens. She liked French cooking and food, and they dined in 'splendid' rooms at long tables in gay company. For a nineteen-year-old girl who had never dined away from home, and who for years had endured the monotonous cookery of her mother's underpaid cooks, it must have been a startling emancipation. In France they could have four courses and fruit, wine and brandy for 1s. 8d.; and the Richmonds were 'kind and good'. Everything agreed with her; the food, the change of air, the white and clean city—so different from London. Knowing the anxieties of his mother-in-law, Samuel was at pains to write that Hannah had survived the journey very well and was in excellent health. It should not have been necessary to state this, as Hannah's happiness and good health radiate from all she wrote, and their joint letter arrived in London on 14 October. He suggested John Linnell

should write to the poste restante in Florence or Milan, where they hoped to be in twenty-one days. But Linnell could not have replied promptly, as they did not have a letter waiting for them in either place when they arrived there.

Samuel's estimate of three weeks to Florence was right. After engaging a *voiturin* through a friend of the Richmonds, they travelled for nine days, from 5 a.m. to 6 p.m. daily, sleeping at 'posh' inns, as Hannah called them. Later he was stimulated to write evocatively of this part of the journey:

> I shall not easily forget some grand old fortified towns near the Swiss frontiers of France. We had just a glimpse of their grey fanes and mouldering battlements before we entered for the night, and left them before daylight in the morning; which, when we looked back, we saw glimmering upon them in the valleys beneath. Sometimes the morning mist filled up the valleys and plains like an ocean with its friths and bays; while the rising sun, striking upon the island-like summits and mountains, fired with living gold here and there an ancient village or city on their glowing ridges. Sometimes what seemed to be sky opened and disclosed a patriarchal village nestled among the pastoral downs, and glistening like silver or pearl through the rarer vapour; or the cloud would partially vanish or rise like a curtain, and disclose a champaign country at our feet; while, on either side of the road, the village people were brushing away the dew from the ripe vineyards, and piling up the purple treasure in baskets, or loading them upon teams of cream-coloured oxen.[1]

Then came the Alps, seen from sixty miles away like sunny clouds on the horizon, and by 22 October the coach had arrived at Lausanne, with its terraces and gardens dropping to the lake of Geneva. Just as Hannah More had found even the lofty cliffs of Cheddar so 'stupendously romantic', and her imagination had been so 'delighted, confounded and oppressed' that she could not refrain from crying, so much more did the sublimity of the Alps overwhelm travellers. Their wonders brought to life all those qualities by which Edmund Burke had defined Sublimity. An awe-inspiring Grandeur, with a strong element of mystery and dread; a Vastness of Dimension in depth, height, and length; Magnificence and

[1] Samuel Palmer to his cousin, Samuel Giles. Pozzuoli, October 1838.

Darkness associated with black and gloomy objects; and an Infinity which produced a 'delightful horror' through immeasurable extension of the imagination. But this journey was no 'delightful horror'. To be climbing the Simplon Pass in late October must have been dreadful and dangerous. As soon as the Saltine, roaring down its gorge, had been crossed at Brigue, with a last startling view back at the Rhône valley, they began their climb. Although it was a new road well built for artillery by Napoleon's engineers, and was the shortest route from the Valais to the Canton Ticino, it still scratched zigzags up gradients of one in eleven, and at that time of year was snowcovered all the way, necessitating a change from wheels to sledges. Starting in darkness at 3.30 a.m., they began the steep and winding climb through the cold air; along walls of perpendicular rock, which the road seemed to clutch; across bridges above steep gulfs through which cataracts foamed; round broad curves below corries scoured by glaciers, and past wayside crosses where travellers had been killed by avalanches. At 6,500 feet they spent the night at an inn at the top under the shadow of the giant Monte Leone, it being too late to begin the descent in safety. However, they may have been comforted to look down on the specks of friendly light in the windows of the tall tower and buildings of the Simplon Hospice, where lived the Austin Canons of the Great St. Bernard.

In the morning they began the slow descent from Simplon village. *Les belles horreurs* of the journey were on this section: just a narrow space for road and torrent with rocks closer than ever, with no apparent gallery cut through the granite, and finally, before Gondo, a dark tunnel for two hundred yards through the rock from which hung clusters of dripping icicles. Then swiftly the snows were left behind and the warm breezes from the south swept up the valleys. Once at Domodossola the vegetation changed, and Hannah noticed chestnuts, mulberries, figs, and vineyards as she peered from the coach window. Passing along the shores of Lake Maggiore, whose waters gradually changed from deep green to rich blue, they would have gazed out on Isola Bella, that princely island palace whose ten terraced gardens rise like a great galley out of the lake. Then to Arona at the southern end of the lake for a night at an inn,

where waking the next morning, opening the bedroom window and stepping out on to a balcony of flowers, they saw 'the sky crimson with the approaching sun behind the mountains of the Largo'. Later they took a short expedition up the slope to the colossal bronze and copper statue of San Carlo Borromeo, the seventeenth-century Jesuit saint who had been born in his father's castle overlooking Arona. This statue, with right hand outstretched in blessing over the lake and valley, is so large that, like the Statue of Liberty, one can climb into the head, and this Hannah and the Richmonds achieved. Samuel, being 'plagued with heavy boots', or perhaps by his asthma, was forced to return before they reached the statue. John Linnell commented on this in his first letter and hinted it was through his fatness, calling him a 'Bartholomew Pig', which signified the largest animal in the Fair. Most likely Samuel was weighed down by numerous objects which he invariably carried in his pockets. After this they passed through Porto Castellato, the next day reaching Milan, where they stayed for three days to rest the horses.

This gave them a chance to see the gothic cathedral, which Hannah thought was 'beyond description' with 'the finest statues; every little nook and corner contains some valuable picture or statue'. Shelley, on his way to read Dante in a solitary spot behind the altar, where the light of day was 'dim and yellow', had seen the cathedral as 'piercing the solid blue with those groups of dazzling spires, relieved by the serene depth of this Italian heaven'.[1] And for Samuel its 'dim religious lights gilded the very recesses of the soul'. But the Palmers' ecstasies did not extend to their visit to the refectory of the Convent of the Dominican friars at Santa Maria delle Grazie, where they examined Leonardo's 'Last Supper'. It was 'a wreck', wrote Samuel, and 'what remains must have been most lovely, but it is in such a dreadful state you can scarcely see it', added Hannah. When Turner saw it in 1839 he also did not think the fresco was worthy of comment: 'Went to see Leonardo da Vinci last Supper, the original—returned by the Corso', he curtly wrote in his diary. It had indeed suffered much during the French occupation between 1796 and 1815, the refectory being used as a forage

[1] Shelley to Thomas Love Peacock, 20 April 1818.

room by soldiers; but even sixty years after it had been painted Vasari said it had been 'so badly handled that there is nothing visible except a muddle of blots'. More has been written on this recently restored fresco than on any other work of art. Its state in the 1930s was fully discussed by Sir Kenneth Clark, who came to the conclusion that what we then saw was mostly the work of previous restorers, who had altered the facial expressions, and sometimes the position of the heads of the Apostles, yet, in spite of this,

some magic of the original remains . . . As we look at them these ghostly stains upon the wall . . . gradually gain a power over us not due solely to the sentiment of association. Through the mists of repaint and decay we still catch sight of the super-human forms of the original; and from the drama of their interplay we can appreciate some of the qualities which made the Last Supper the keystone of European art . . . Unity and drama, these are the essential qualities by which Leonardo's Last Supper is distinguished from earlier representations of the subject . . .[1]

Evidently Hannah and Samuel had not realized the sad state of 'this illustrious invalid';[2] but one would have expected them to appreciate the innate qualities of the fresco. However, they admired the Leonardo chalk drawings in the Ambrosiana Library.

On Tuesday, 31 October, they left Milan for Florence, without stopping on the way except for meals and sleeping. Their passport for the rest of the journey is smothered with stamps for visas, indicating the many states through which they passed. The kingdom of Piedmont, the autonomous Duchies of Parma, Modena, and Romagna (Bologna), the Grand Duchy of Tuscany (Florence), and lastly the Papal State (Rome). *En route* for Florence, Palmer climbed to examine the Correggio frescoes of the Assumption in the cathedral at Parma; but once again he was disappointed by their condition. After supper at Bologna the Palmers and the Richmonds walked through the dark arcades flanking the streets, admiring the many churches, brick palaces, and tall towers silhouetted in the

[1] *Leonardo da Vinci*, Cambridge, 1939, pp. 95–6. The fresco has been superbly restored since that date.
[2] Henry James, 'From Chambéry to Milan' in *Italian Hours*, London, 1909.

moonlight. On 8 November, after a glorious journey over the Apennines, past villages perched on crests of rock and summits of hills, they descended to the cultivated plain of Florence, as the mountains receded into the pellucid Italian air. Being informed the cholera epidemic in Rome had died down, they decided to stay only briefly in Florence before pushing on.

The cholera had been at its worst during the spring and summer of the year, despite *Cordons Sanitaires* round the chief cities to prevent travellers from entering or leaving. In Rome it was like the plague in the *Decameron*. Those nobles and the Pope who were not able to leave blocked up the doors and windows of their palaces, hoping to prevent contact with a city in which dead bodies were being thrown into the streets. By November, when the Palmers arrived, there had been 15,000 deaths, but the epidemic had abated. In Naples, despite fumigation, letters in vinegar, and decrees that any physician who deserted his post would be shot, the disease raged unchecked until the winter.

So for three days the Palmers were taken round Florence by an eccentric English artist whom they had met. He used to spend his winter evenings at the opera, as it was the cheapest place in which to keep warm, the pit costing only $2\frac{1}{2}d$.! As well as taking them to a *trattoria* where artists met—and Hannah was pleased to find one who had heard of her father—he showed them some of the city's treasures. The Duomo, Giotto's Campanile, the Baptistery doors; and Andrea del Sarto's frescoes in SS. Annunziata, depicting scenes from the life of S. Filippo Benizzi, the founder of the Servite order, and from the life of the Virgin. The fresco of the death of the saint with the little boy being simultaneously brought back to life by touching the dead saint's garment, appealed to Hannah on account of its sentimental subject-matter, and the detail of the facial expressions. She thought she would like to copy these frescoes when they returned to Florence at a later date; and she compared them to the work of William Mulready, her father's friend, because of 'the kind of finish and beauty of colour'. The scale and subject-matter of Mulready's painting are similar to Dutch nineteenth-century genre scenes, so, except in as far as Hannah saw, there are no further points of comparison.

The Palmers had time in their wanderings round the city to admire Michelangelo's 'David', which then stood outside the entrance of the Palazzo Vecchio, and the statues in the Loggia near by. Hannah also mentioned two pictures in the Uffizi which made a special impression on her: 'a Raffaelo' and 'an Albrecht Dürer'. The first would have been the 'Madonna del Cardellino', painted on wood in 1547, one of the open-air series of Madonnas with delicate trees in the distance forming poetic spaces round the group. Mary's outline—she wears a blue cloak over a red robe—protectively encloses the two children who stand at her feet. The boy St. John holds a goldfinch cupped in his hands, while the Christ child makes a gentle gesture over the bird's head as if to protect it. In 1837, it was under coats of varnish and discoloured by subsequent overpainting, and not as we now see it. The Dürer to which she refers must have been 'The Adoration of the Magi' in which the Virgin and child are seated in the foreground in profile, with the Moorish king nonchalantly standing framed by the lighter part of the landscape, while another of the kings stands majestically in a Leonardo-like pose in the centre. The third king, the older man, kneels with reverence. All the human figures in this painting clearly show the Renaissance belief in the dignity of man, the quality which so many of the arts of the Italian Renaissance emphasize.

In a letter to her father, full of optimism about their approach to Rome, she wrote that Mr. Richmond had many letters of introduction which he would use for them also. It was a vain hope; George and Julia Richmond knew many of the English set in Rome who were both social and rich, which precluded the Palmers, who were neither, though on arrival they were certainly helped by Joseph Severn, who was an old friend of Richmond's. So they carried on with a *voiturin* whom they hired to drive them through Arezzo, Perugia, Spoleto, and Terni. As they wished to reach Rome, and were paying for the driver and carriage by the day, they did not tarry at the Falls at Terni—a most popular place for all artists. The bad inns and the low average of thirty miles a day on the last part of the journey through the Apennines were forgotten as soon as the cupola of St. Peter's, a distant speck across the *Campagna*, came in sight at the seventh milestone. Showing their passport and other

essential forms, they soon passed through 'the villainous ordeal of the papal customhouse',[1] at the Porta del Popolo, on the evening of Tuesday, 14 November.

The next day Hannah got off a letter to her parents describing the last part of the journey. Julia Richmond also wrote to Mrs. Linnell, reassuring her at some length that Hannah was looking 'fuller and better' after the journey. This emphasis on health in the correspondence with Mrs. Linnell is common. It was a time of strange ignorance in medical matters resulting in bogus remedies, many of which Mrs. Linnell and even Palmer followed. In 1848 Palmer wrote to Julia Richmond, then in the country, after the cholera had broken out in London:

I have provided myself with the Arabian specific useful at the first outbreak before medical advice can be had; the great thing is to do something *instantly*—2 grains opium, 2 do. Assafoetida, 2 do. Black pepper—one dose, kept ready in pills, the pills to be crumbled, or *chewed (according to taste)*, & each taken with a tablespoonful of brandy & water. Tight ligatures of tape (in absence of tourniquet) just above both knees and elbows, to keep blood from rushing to extremities.[2]

To return to medical matters in Italy: Mrs. Richmond continued her letter to Mrs. Linnell with a reference to a 'Scotch physician, a very agreeable man' to whom she was recommended. One hopes he was a better doctor than was Sir James Clark, another Scottish physician once in Rome, whose kindness to the dying Keats did not compensate for his professional inadequacy. However, it transpires that Mrs. Richmond did not require the doctor for professional reasons, although, in fact, she was due to have another child in two months,[3] but merely because he had recommended her what she called 'a female' to attend her. The term, implying contempt for simplicity or ignorance, was used by the early Victorian middle class for a woman of low degree. This usage evidently disgusted Lady Callcott,[4] wife of the landscape painter, and a neighbour at

[1] Nathaniel Hawthorne, *The Marble Faun*, Boston, 1860, Chapter XI.
[2] Richmond MSS.
[3] She gave birth successfully to Mary in January. She was her fifth child, three having died as infants.
[4] A much-travelled woman, authoress, under the name of Maria Graham, of

Kensington of the Linnells, who once startled a party by stating she would sooner be called a bitch than a female. Evidently the Palmers and the Richmonds, were looked after well from the moment that they arrived in Rome, as Julia Richmond mentions that Joseph Severn was then taking her husband with Hannah to the Vatican.

George Richmond's friendship with Joseph Severn, the portrait painter, went back to the days when they had been together in the Royal Academy class which Severn had attended as an apprentice. On one occasion, when they had gone together as students to a lecture given by Turner, they found that every seat had been taken, and they were refused admittance. Severn, as the elder (Richmond was only fifteen), appealed to Henry Fuseli, who was in charge of the Academy painting school. His reply to Severn is typical of his disillusioned opinion, at the end of his life, of the state of art in England: 'Offer any of the audience a pot of beer in exchange and you will get a seat anywhere and at once.' Since the death of Keats, Severn had stayed in Italy, and his devoted friendship with the poet had become 'a kind of passport to the English in Rome'. He found himself, he wrote, 'in the midst of not only the most polished society, but the most Christian in the world—I mean in the sense of humanity, of cheerfulness, of living for others rather than ourselves'. No one could have been a better guide to Roman art or social life. The young Ruskin thought Severn 'understood everybody, native and foreign, civil and ecclesiastic in what was nicest in them'.[1] With his wife and family Severn had only just returned from Olévano, forty miles away in the Apeninnes, where they had lived safely during the Roman cholera epidemic. Yet it was typical of this vivacious little man that he should be recommending lodgings for the Palmers, and hurrying to the Vatican to arrange passes for them on the day after they had arrived in the city.

It had been a most stimulating journey in glorious weather, especially during the days in Paris, Milan, and Florence. Hannah had survived admirably, and Samuel had had the opportunity to

Little Arthur's History of England, 1835, and *Three Months passed in the Mountains East of Rome*, 1821. Her unfinished portrait by Lawrence (he worked for only two hours on it) is in the National Portrait Gallery.

[1] John Ruskin, *Praeterita*, Vol. II, Rome, 1899, Chapter 2.

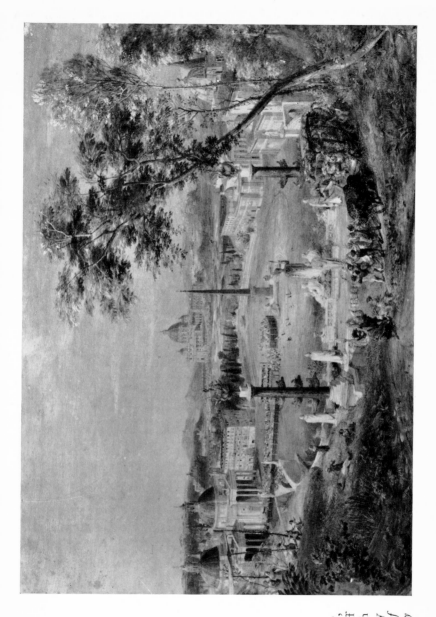

5. 'Modern Rome', water-colour on buff paper over pencil, with body-colour, by Samuel Palmer. *City of Birmingham Art Gallery*

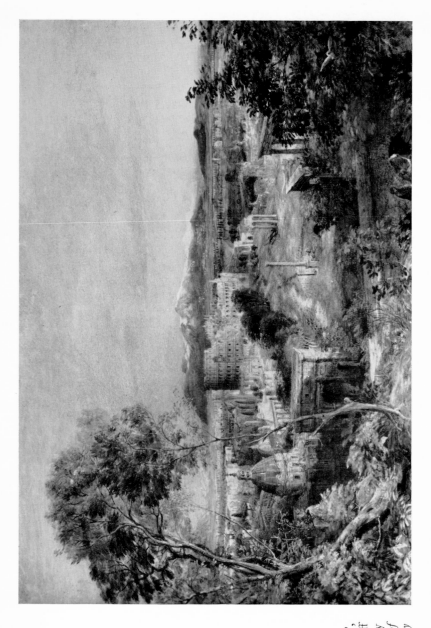

6. 'Ancient Rome',
water-colour on buff
paper over pencil, by
Samuel Palmer. *City of
Birmingham Art Gallery*

sketch many of the 'celebrated castles and striking effects' on the way.[1] Except for her tears of home-sickness when she did not find letters for them as she hoped at Milan or Florence—which she would have liked 'more than anything else in the world'—there had been nothing which jarred. They were very happy to be in Rome together, and Italy with its air, light, and sky immediately spread its magic over them, providing many promising subjects for painting.

[1] One of these is from a sketch-book, $10\frac{1}{2}$ inches by 5 inches, water-colour over pencil, heightened with white, inscribed in Palmer's hand, 'Cadenabbio'. He was often inaccurate in spelling place-names, and he means 'Canobbio' on Lake Maggiore, which he has drawn with the mountains towering over it. I am grateful to Mr. Carlos Peacock for showing me this drawing.

Rome, Spring 1838

> This wonderful art can take us away from ourselves and give us the feeling of being identified with the universe, perhaps even of being the soul of the universe.
> BERNHARD BERENSON, *The Italian Painters of the Renaissance*

THEY had to wait until Christmas week before they received letters from Hannah's parents. It seems that a previous letter which her father had sent poste restante to Florence had gone astray, or perhaps had arrived after they had left (it was never found), so he had not written again until after 2 December, when he had received Hannah's letter from Rome. Linnell started his letter gloomily by announcing George Richmond's father's death, the news of which he said Samuel should impart to the Richmonds.[1] (Why could not Linnell have written another letter to them?) Then he stated that the Palmers' house in Grove Street had not yet been let; this was serious news, as they needed the money from rental. But the most depressing part of the letter is the hypochondriac strain which runs through it like an impurity in the blood-stream. He was afraid Hannah might be staying too long in the cold and damp of the Sistine chapel, so he suggested she take along with her a wooden board to stand on. (Could he not have had faith in Samuel's ability to look after her?) More pessimistically, he

[1] 'Heard of my dear father's death.' George Richmond's *Diary*, 21 December 1837.

thought because she had not as yet felt any ill effects from the change of food she should not presume she would not. To exemplify this he inaptly quoted Bacon that 'always with an inclination to the more benign extreems so shall nature be cherished and yet taught masteries'.[1] The 'benign extreems' which presumably she would have to check on, being full eating rather than fasting, sleep rather than watching, and exercise rather than sitting. Would she have had a copy of the *Essays* with her or did he think she knew this passage?

However, there was a copy at 38 Porchester Terrace, of Mariana Starke's *Letters from Italy*, and the Linnells' pessimistic fears about Italy exactly match the advice given by this 'Delphic oracle of travellers'. Before allowing them to see the Vatican this authoress warns them that

many parts of this immense building are extremely damp and cold; the Museum is especially so; and Persons who go thither previous to seeing other parts of the Palace, should send a servant to get the door opened before they quit the carriage—otherwise they risk standing a considerable time in an eddy of cold damp air.

Later she gives similar counsel about the cloth shoes which could be bought cheaply in the streets, and which should be worn as overshoes to 'mitigate that dangerous chill which is the inevitable consequence of remaining long in large, damp and uninhabited apartments with marble or brick floors'.

Although Linnell admitted he liked Hannah's letters, he was mildly critical of the 'bathetic way in which she wrote in one breath of "statues fine in niches and stockings dropping stitches", like Swift's *Meditation upon a Broomstick*. But it is just this freshness and spontaneity which gives Hannah's letters such unsophisticated sincerity. Like Polonius, Linnell then gave unasked-for and conventional advice: she should learn to speak Italian, should go to the opera, and have singing lessons, for which he said he would pay. But they had neither time nor inclination for regular opera-going or singing lessons. Usually, after working all day in the Vatican, Hannah felt like dropping asleep, as she once did at one of the

[1] *Essays*, 'Of Regimen of Health', London, 1625.

Richmonds' parties. Linnell wrote he had completed Sir Robert Peel's portrait, having much enjoyed conversing with him as a sitter. This was understandable, provided that they did not discuss politics, but stuck to art matters. Peel was the greatest patron of the time, other than a prince, and had made a fine collection of the Dutch and Flemish schools, though he obviously had not the taste and knowledge of an earlier patron like Sir George Beaumont. Rubens's 'Chapeau de Paille'[1] and Terborch's 'Young Woman playing the Theorbo to two men' were bought from his family for the nation in 1871. Peel would also have been able to tell Linnell something of Rome—although not about the people with whom the Palmers were mixing—as four years previously he was hurriedly sent for from a ball at the Princess Torlonia's, in order to become Prime Minister for a brief period.

Linnell also asked the Palmers to tell Joseph Severn what a delightful task it had been to copy his portrait of Keats.[2] All through his life Linnell enjoyed endless copying of the works of the Old Masters and others. Then family news was related lightly: of little Tommy who had been singing the hymns of Dr. Watts to the tune of Jim Crow, a popular negro minstrel at the Adelphi theatre in 1836.

Mrs. Linnell wrote with anxiety for the future and alarm that it was so long since she had heard from them. They ought to have posted a letter in Florence or Milan, although they had been in each place for only two or three days. The benefits of postcards for brief news were not then known to them. In an impersonal way Mrs. Linnell hoped Hannah would be happy to remain in Rome, in order that Palmer could 'gain all the improvement he so confidently expected from visiting Italy'. (To which, he would have had no difficulty in remembering, she had been opposed.) A cheering note worth all the rest was added by Lizzy, who was glad they were enjoying themselves, and wished them well.

Unfortunately, they were not able to work in the Sistine Chapel,

[1] 'Rubens' wonder picture', according to Jacob Burkhardt, author of *The Civilisation of the Renaissance in Italy*.

[2] Severn's sensitive portrait of Keats seated, reading a book, is currently relegated to the vaults of the National Portrait Gallery. Linnell's half-length portrait of Peel, though not his best work, can be seen in the same Gallery.

as artists were not being given permission to enter until mid-January on account of certain ceremonies which were taking place. This was a great disappointment to Anny, who had to content herself with colouring mezzotint-engravings of the Raphael Loggia. Describing this work as 'tracings on a small scale rather than copying parts of the frescoes', Palmer thought there would be nothing of the kind in England. Today, we who are accustomed to colour photography and reproductions of all kinds, may find it difficult to realize how much such work must have meant to those who had never seen the original frescoes. In 1518 Raphael and his assistants had completed the decoration of the Loggia (thirteen vaults of fifty-two scenes from the Bible) overlooking the Cortile di San Damaso, beyond which was a panorama over the whole city to the Alban hills. The glazed Loggia faces south, so Hannah might have worked in bright sunlight, but as it was unheated, there were cutting draughts in winter, and hot-house conditions in summer.

Palmer was overwhelmed by Rome: by the superb decorations in the churches, by the white marble friezes against the blue sky, by teams of bas-relief-like oxen, by the antique ruins and the processions of monks. Above all, by the sunshine, the very poetry of light which on every bright day seemed new and magical. As yet the Roman winter had not set in, but they were soon to realize the mean average temperature of Rome is only five degrees Fahrenheit above that of London, and the rainfall is higher. Writing also to his mother-in-law, Samuel endeavoured to calm her anxieties, as letters might be held up by heavy snow in the Apennines. He added that he looked forward to returning to Grove Street, where there would be only a 'wooden bridge'[1] to cross in order to visit them in Porchester Terrace. So with a brief note to Lizzy and another to his father, with love to all the children, the letter was sealed.

Replying on 4 January, John Linnell hoped they had seen St. Peter's illuminated, and he took the opportunity to describe at length an expedition—a rare occurence for his children—which he had arranged in order to see the illuminations in the City after the

[1] Over a basin of the Paddington canal (now Bishops Road bridge). Grove Street has since been swallowed in Paddington goods yard. It was about a mile and a quarter's walk from Porchester Terrace, across fields part of the way.

State Visit of the Queen on 9 November. Taking his three boys and his pupil, Albin Martin, he hired a fly, started by the Bank, through Cheapside, St. Paul's, the Exchange and the Strand. A great night for John, James, and William Linnell, who, warmly dressed in tartan coats over their 'smock frocks', stood up in the open carriage to see the sights better. It must have been thrilling for all observers, because gas as a decorative medium was being used on a large scale for the first time. The jets were startling along the route: coloured lamps in various tints, interspersed with laurels, wreaths of roses, flags, and drapery, all in the art of transparency whereby a picture on a translucent substance is made visible by a gas light behind. In the narrow part of the Strand the Linnell boys began to find the glare from the lights was oppressive, the bustling of the crowds was tiring and the night air was cold on the ears, so they returned to Bayswater at 2.30 a.m.

This scene was cheerfully related by John Linnell; then abruptly he turned out the lights and made a dark attack on Samuel's religious views. Seizing on Samuel's harmless mention of a 'wooden bridge' which in future might be *en route* between their two houses, he extended the metaphor and accused Samuel of 'keeping another bridge in repair for some years, which is rather a barricade than a communication'. This he called the 'Asses' Bridge of Superstition, built with nothing but the rubbish of human tradition, obscure, false, and fraudulent—a few court-place bricks and bad mortar laid on too thick with a trowel. But what is worst of this bridge is that it is built across the common footpath where there was an excellent road made by divine Authority.'[1] Then he added sarcastically, 'herein I see the benefits of travelling, not only to the party removed but to those remaining at home, which are that the affections of the heart are perceived and felt in their true proportions, and the nature of all the contemptible impediments to charity more clearly understood'. Strong words these, and Palmer must have realized that nothing arouses the passions more than religious controversy, and especially in the case of his father-in-law, who had veered from being

[1] This remark is apparently misinterpreted by Geoffrey Grigson in *Samuel Palmer, The Visionary Years*, 1947, p. 69. Linnell was referring to Church practices, not to Palmer's 'mystical view of nature'.

a Baptist to a position in which he accepted the dogmas of no authority other than his own conscience. According to Alfred Story, his biographer, Linnell wrote much satirical verse on religious subjects. The following example, with its volleys fired at both Rome and Puseyites, is typical, although its final couplet seems to miss the mark.

> The monster he exists in Rome,
> Diluted it is seen at home—
> Priesthood set up, the Antichrist foretold,
> Taking the place of Him who from of old
> Was true High Priest, who coming did fulfil
> All priestly types, and of his own free will
> The sacrifice became for all, even the least,
> And therefore no longer sacrifice, no longer priest.

Also Linnell may never have forgiven Samuel for taking Hannah and Lizzy to St. Paul's on Sundays, thereby ensuring their loyalty to the Church of England. Any mention of Catholicism was obviously anathema to him; but how could he have taken exception to Palmer's comments on the beauty of the decorations in the churches or the fine processions of monks? He would certainly not have been amused by the story of Joseph Severn and George Richmond visiting S. Giovanni Laterano to find a crowd of poor people prostrated in front of a large portrait. They recognized it as Lawrence's portrait of George IV which had been presented to the Vatican. On inquiry, from the right quarters, Severn discovered it had been removed in error during redecorations in the Vatican, to S. Giovanni Laterano, where it was being mistaken for a picture of a newly canonized saint. Any mention of Lawrence was not pleasant for Linnell, who thought there was 'a worldly taint of corruption, of Fashion and Vice'[1] in most of his work, especially if contrasted with Reynolds, whose work had far more 'taste and moral perception'. Palmer did not feel this, nor, despite constant attacks from Linnell, did he waver in his Protestantism; yet he could see further into religion than the outward and visible differences of various sects. So he never took up the provocations of Linnell's religious views; and

[1] John Linnell's *Journal*. Ivimy MSS.

Linnell, being, as he says, 'a heretic', and delineating his 'limits as narrow', rightly decided on this occasion to stick to matters of topical interest. Linnell therefore described a come-back by Charles Kean, the son of Edmund, in what was an elegant, unbombastic performance at Drury Lane of *Hamlet*.

Mrs. Linnell's letters usually concentrate on family news, domestic matters, and the weather. Edward Calvert's mother had died in Cornwall, Samuel's father was living on the second floor at Grove Street, there had been a change of servants and it was a very severe winter. Indeed, it was exceptional—no winter since 1814, when there was a Fair on the Thames, had been like it. On the night of 18 January the ice was a solid mass in front of the Tower of London, and when the tide rose, huge blocks of ice were dashed against piers and bridges.

In Rome there had been much rain through which every day Hannah had trudged the two and a half miles to the Vatican. No Italian woman of similar social status would have been seen walking in the streets, which, without pavements, were repositories for filth and rotting vegetables thrown from the houses—often quagmires in winter. The inhabitants of those houses which she passed must have become accustomed to the daily regularity with which this fair-haired little Englishwoman, in the same flowered bonnet, used to walk purposefully by with sketch-books, stool, and portfolio, and frequently they would call 'piccola inglese' after her.

The Palmers' lodgings in a house which they shared with the Richmonds, paying a quarter of the rent, were at the top end of Via Quattro Fontane, then one of the highest and healthiest places in Rome, where many artists lived. Every morning at nine o'clock she would set out on her daily trek to the Vatican. After five minutes she reached the church of Trinità dei Monti overlooking the Spanish Steps, where she would pause to gaze over the roofs at the magnificent view of St. Peter's, her objective, on the other side of the Tiber. Then she started to descend that splendid staircase of travertine stone (three flights and three landings alluding to the church of Trinità dei Monti), on which country folk, picturesquely dressed in their native costumes, waited to be hired as models by English artists. Wilkie Collins noticed the man who could dress as a

peasant in the morning or a prelate in the afternoon; the beautiful boy as a cupid for the artist, but a stiletto-wearer at home; the dark-haired peasant girl, straight from the *Campagna*. 'One old gentleman with long white hair and immense beard', according to Dickens, had 'gone half through the catalogue of the Royal Academy'. Was he the model for the old fellow playing the bagpipes whom Samuel drew? Most likely not, as about a month before Christmas the peasants from the Abruzzi used to leave their mountain homes and walk to Rome—as they do still. Always in couples, one of them playing a *zampogna* or bagpipes as accompaniment, the other a *piffero*, or pastoral pipe, for the melody. When they reached the city they played together at shrines, at the corners of streets, in the courtyards of *palazzi*, in the Corso and inside restaurants. They usually wore conical felt hats with frayed peacock feathers, red waistcoats, blue jackets made of skin or homespun cloth, with a cape buckled round the neck. Some of these details, and skin sandals with cords up to the knee, can be seen in Samuel's drawing.[1] Sometimes the bagpipes interrupted the sleep of the inhabitants of the city; nothing was 'so infuriating as to be awakened in the middle of the night by the lugubrious sound of the pipes of these people'.[2]

On her way to the Vatican, Hannah would hurry past all these peasants on the steps, the beggars with the withered legs, and Keats's burnt-umber house, where the dying poet cared for by Severn had heard from his bed the chatter from the steps. With a glance at Bernini's curious fountain, La Barcaccia, a deliciously water-logged stone boat into which the water pours, around which Hannah would have seen horses brought to water, boys bathing, or washerwomen slapping the clothes, on she went into the narrow Via Condotti. Then passing the Caffè Greco, where the German artists congregated, straight on over the Corso, past the great iron grilles of the Borghese palace windows, by markets in back streets, to the broad Tiber, ochrous when the sun shone, and not strait-jacketed as now by high embankments. Across Ponte S. Angelo, through two lines of Bernini angels, with their gay draperies

[1] *Life and Letters*, p. 234. Water-colour, $11\frac{7}{8}$ inches by $8\frac{5}{8}$ inches.
[2] Stendhal, *A Roman Journal*, London, 1961.

seemingly blown by the wind even on the calmest day, skirting the vast brick mass of Castel S. Angelo, into a narrow street to the colonnaded piazza of St. Peter's.

After much work, by the middle of January she had finished a water-colour drawing of the Raphael fresco, the 'School of Athens' in the Stanza della Segnatura. It is easy to understand the fascination at that time for line drawings of Raphael's paintings and frescoes, as photographic reproduction was unknown. Linnell may even have been fascinated by the possible benefits accruing from their sale. However, an artist of the stature of Blake realized the limitations of line drawings. When asked to draw 'three sublime designs of Romney', he had found them 'all too Grand as well as too undefined for meer outlines . . . nothing less than some Finish'd Engravings will do, as Outline intirely omits his chief beauties'.[1] Even more ineffectual are line drawings (even the Cartoons) of these great Raphael frescoes divorced from the Stanza. For the ennoblement of the figures is inseparable from the spatial and architectural setting of classical arches in the comparatively low-ceilinged room. In 'The School of Athens' the figures of Plato and Aristotle, on whom everything converges, face each other centrally. Plato points to the sky, and all the movement in the fresco centres on this gesture, the symbol of all the Arts, Sciences, and Philosophy being secondary to divine matters. Around Plato and Aristotle stand other philosophers; with the half-naked cynic, Diogenes, seated on the steps, and Pythagoras writing harmonic tables.

One day, as Hannah was close to the Basilica, she crossed into it to witness a Solemn Pontifical Mass. To the accompaniment of 'band', organ, and vocal music, the aged Santo Padre, Gregory XVI, dressed in white, 'preceded by priests in purple silk with large white tippets, then by cardinals in scarlet', was carried in a rich canopy of velvet 'on the shoulders of twelve clergy, with men by his side bearing large things made of feathers the shape of hand screens only of immense size'. In Hannah's eyes he was not an impressive figure, appearing more like a woman, or like a figure which boys carry round on 5 November. Yet she may have been moved at the moment of the elevation of the Host, when the guards, with swords

[1] William Blake to William Hayley, 22 June 1804.

clattering, dropped to their knees, when the sound of trumpets swelled in the dome, and the shrill ecstasy of falsetto voices pierced the air. But she was disgusted by some Catholic ceremonies. One in which two lambs were blessed by the Pope and afterwards killed to provide skins for monks' cowls was a 'superstition' which especially offended her sensibilities. The Palmers were happy to attend Anglican services with a 'kind' clergyman in the Church of England chapel outside Porta del Popolo. They could not regard any church scenes as subjects for painting, as did William Collins, R.A., the friend and neighbour of the Linnells, who was soon to arrive in Rome.

Every evening when she returned from the Vatican she could see from far off the western sun glowing on the twin belfries of Trinità dei Monti at the top of the 135 steps. Then she and Samuel would join other artists for dinner at a *caffè* which was just down a passage from their room. Usually they sat at a long table with John Gibson, the sculptor, recently an R.A., who had been in Rome for some years, gradually becoming ignorant of what was going on in the English art world. How many now know his work? Queen Victoria enthroned and flanked by Mercy and Justice in the dark-panelled, encaustic-tiled Princes Chamber of the House of Lords; or Hylas and the Water Nymphs in the Tate; or Sir Robert Peel in the white, silent marmoreal company of Canning, Castlereagh, Palmerston, Disraeli, and Gladstone in the north transept of Westminster Abbey; or Huskisson in a toga? Welcomed in Rome by Canova, and pupil of Thorwaldsen,[1] Gibson had remained happy and simple, with 'a peculiarly grave, immovable expression of countenance'—an ideal companion for the Palmers, who found difficulty in dealing with the manners and conversation of the *palazzo* set, of which Gibson was the antithesis, lacking, according to Palmer, any 'polite hauteur or insulting condescension'. Both he and Severn were devoted to Rome, where they found there were more commissions; and the social status of artists was considerably better than in England, where they were regarded as superior tradesmen. In 1829 Gibson,

[1] Then living in Rome: 'a most delightful person in his manners, and in his appearance, everything one would expect in a man of poetry and art'. George Richmond's *Diary*, 27 November 1837. Richmond MSS.

proposed by Baron Camuccini, had been the first Englishman to be
accepted for the Academy of St. Luke in Rome. He was most kind
to the Palmers, taking them to the opera, giving Hannah a cast of
one of his bas-reliefs and a 'pretty little wooden box' which he had
made on purpose for travelling, and which she kept all her life.
Unfortunately, much of his work is little more than the Greek
tradition rehashed; an 'emasculated Greek', as Fuseli called Canova.
Gibson's 'Narcissus' sent to the R.A. in 1838, and still in Burlington
House, is typical. At the same table in the *caffè* sat Gibson's brother
Benjamin, an amiable young man, a sculptor also, who had just
joined his brother to assist him professionally and domestically.

On the chart (Plate 4a) which Palmer drew can also be seen the
name of Penry Williams, another painter who lived in Rome and
sent work regularly to the Royal Academy between 1822 and 1869
from his studio near the Spanish Steps. The subjects of his paintings,
like those of Thomas Uwins, are mostly romantic 'properties';
portraits of *pifferari*, *lazzaroni*, *banditti*, or *festa* scenes brightly and
carefully painted. In fact, what the Victorians liked to imagine were
Italian landscapes colours. Murray's contemporary handbook writes
him up in glowing terms, and his patrons later included the Prince
of Wales and various ducal personages. Although he was the son of
a Merthyr Tydfil house painter, Williams seems to have had no
difficulty in dealing with aristocratic patrons. In a letter to Severn,
Uwins writes of him, 'If distinguished talent, liberality, good taste,
with gentle amiable manners, are likely to insure success, his cause
will be always prosperous. . .' Had Palmer remained in Italy he
might have painted in a similar genre. Fortunately, like Eastlake
and Wilkie before him, he avoided the inducement. Another regular
diner at the same table was Thomas Dessoulavy, R.A., who lived
in Via Felice. Between 1829 and 1848 he sent six 'Views of Rome' and
one other large canvas to the R.A. Like Gibson, he was much help
to Samuel, especially when he showed pictures in the Rome
exhibitions, giving him frames and choosing the best place to hang
them.

The meals at the *caffè* were cheap and the company delightful.
All were charming to the sparkling and buoyant Hannah, the only
woman at the table. Nevertheless, Samuel thought that the habits

of after-dinner conversation 'soured'. One would have thought that after working all day he would have relished the evening's relax-ation. Yet his serious frame of mind required discussion of more momentous matters. To be sure, he obtained these in his correspond-with his father-in-law.

As a letter writer, John Linnell has an ability to switch with astonishing rapidity from a purple passage of expository philosophy to practical details of life.

We are all delighted with the account of your happiness because your enjoyments are of so pure and intellectual a character arising from the study of the sublimest works of creation and Art connected with the pure gratification and the holiest affections, and though you cannot expect that happiness can continue uninterrupted through life, yet it is a great thing to have realized the utmost good which this world can contain. May you long enjoy it. Your song is now the 'Songs of Innocence'. You have still the 'Songs of Experience' to learn; and may the discords characteristic of the music of experience be so gently touched and divinely arranged as only to enhance the Charm of the united songs.

Like gamboge, this prose-style with extended metaphor and balanced cadence, can be used as a pigment or a purgative, and he gets down to business at once in the next paragraph, with reference to the Sistine chapel frescoes.

Let me entreat you not to fail to make all the memorandums you can of them, particularly of the heads . . . Pray do not hurry over the set you are doing for us as I assure you I will most honestly remunerate you for whatever time you may spend upon them. And if Mr. Palmer will give you any assistance I shall be glad to have it at any price he will charge me. Make also separate studies of parts which differ from the prints and are better. Do not attempt to make any allowances for time but copy the present appearance of the Fresco particularly if you like the effect of it, as it is almost impossible to make any difference and retain the better part. Get some coloured memorandas of the Last Judgement if possible. Perhaps Mr. Richmond will be kind enough to make some memoranda of some part of the great work as a memento of his visit, some head or two. Two heads are better than one and I am sure he will not put his foot in it—pray

give my best regards to him and Mrs. R. and say I will not forget all the kindness he has shewn you.

Thus does Linnell hope to involve not only Hannah and Samuel, but also George Richmond, who avoided inclusion, so disappointing Linnell by his lack of communication by letter on art matters. 'The discords characteristic of the music of experience' must have sounded relentlessly and harshly as day after day, from 9 a.m. until 4 p.m. in the winter damp of the Sistine Chapel, Hannah laboured with her tremendous task. This was the colouring of a set of prints from her father's own mezzotint engravings (referred to by Ruskin in *Modern Painters*), from drawings which in their time had belonged to Lely and Reynolds, and which Linnell thought were Michelangelo's original working studies. By the end of January, Hannah had finished ten of them, and was pleased with the result. 'They look like drawings, they are so exactly like with a few exceptions, in light and shade and form.' And Samuel thought that Linnell's prints were the only copies which gave the general character and effect of the originals in the chapel. But 'no engravings or lithographs were able to give the tenderness with which the strongest muscles are effectively expressed, nor the breadth of the lights.' Later in the letter in which Linnell gave her the first commission, he heaped Ossa on Pelion by hoping that she would be able to 'bring home some coloured miniatures of the Loggia subjects. If I did not give you the commission pray accept it now.' The extent of this work in addition to the Sistine Chapel much frightened the Palmers, especially as some of the heads in the Last Judgement in the Sistine could not be seen clearly without a scaffold. But it was not the end of his requests. Later on he mentioned Titian's St. Peter Martyr altar-piece[1] in S. Giovanni e Paolo, which Samuel might like to copy; and even Mrs. Linnell suggested that the church ceremonies might make a 'saleable' picture, though she incongruously added that Hannah should not work too hard.

There are two sketches in the margin of Linnell's letter which illustrate his wish that she should not be outspoken about religious ceremonies. He was afraid letters might be opened or words re-

[1] Possibly the most copied painting in Italy; destroyed by fire in 1867. If Aretino and Vasari are to be believed, it was Titian's finest.

ported. There may have been wisdom in this advice (not that he followed it), as it happened occasionally that letters were inspected, although it was dangerous liberal sentiments in politics rather than in religion that the authorities more feared. In fact, it was well known that Rome was a police state controlled by Austria. Linnell did not know that the Palmers sometimes saw newspapers lent them by the Richmonds, so he told them of three large fires in Europe, reported by *The Times.*

All these occurred within about a fortnight: The Imperial Palace, St. Petersburg; the Royal Exchange, London; and the Opera House, Paris. All started at night, and the very severe winter—it was 50° Fahrenheit below freezing in Russia—caused the water to freeze in reservoirs, conduits, and hoses, so all the buildings became total losses.

It was cold also in Rome and especially in the higher parts of the city where the Palmers' room had no fireplace. In early February, Mr. and Mrs. William Collins, friends of Hannah's family, arrived in the city from Naples, with their two boys, Wilkie and Charles. *They* were certainly able to afford fuel for fires. William Collins was then a successful portrait and landscape painter who could receive £200–£500 for a painting[1] and whose home with his studio was in Porchester Terrace near the Linnells. The two families saw much of each other, Wilkie, aged fourteen, being a contemporary of James Linnell. Some years earlier Collins had had his portrait painted by John Linnell, whom he had known since his student days. The Collinses had been in Italy for two years, and in 1837 had insisted, despite advice from Gibson and Severn, on going to Naples during the start of the cholera epidemic just before the cordons were thrown round the city. But the extent of the disease had frightened them, and they had gone on to Sorrento on the south of the Bay. There, in the height of the summer, Collins had contracted rheumatic fever, and despite the ministrations of a Scottish physician, who had sent him to salt baths on the island of Ischia, he had not recovered before the middle of October. Indeed, he never fully got well before his death in 1847. As an established portrait painter he moved in an aristocratic group of patrons whom he visited: Sir Thomas Baring at Stratton Park in Hampshire, Sir Robert Peel at

[1] One of his pictures sold for £1,700 in 1966.

Drayton Manor in Warwickshire, Sir William Knighton, an amateur artist with whom he shared a studio in Rome, and Sir Henry and Lady Russell with whom the Collinses had been in Naples. His greatest friend, Sir David Wilkie, after whom his son was named, who also lived in comfortable circumstances half an hour's walk from Bayswater, was in the middle of composing a splendid 'picture of state' of Queen Victoria at her first Privy Council, having already had sittings of Her Majesty. Just before the Collinses' visit to Rome, Hannah had had an illness which must have been bronchial, as her doctor said it was aggravated by a stove in her room, which was burning wood-ash, but was smokeless and without a chimney. These stoves were common at the time, and the Severns had one in their nursery. After much discussion, the Palmers had decided not to tell the Linnells of the incident, as they knew how much it would worry them, and they asked Mrs. Collins not to mention it. However, on her return to England in December 1838 she not only told the Linnells of Hannah's illness, but exaggerated by saying the stove was burning 'small coal'. The Linnells were appalled, and reacted as would be expected. So also does A. H. Palmer in a typical comment on the letter, referring to the Collinses as 'litigious, quarrelsome, meddlesome, treacherous, spiteful and arrogant'. However, George Richmond thought otherwise, and quickly made Collins's acquaintance in Rome, subsequently spending much time with him looking at the Vatican museums. The Palmers saw little of the Collinses while they were in Rome; firstly because Collins's studio in the Corso was some way from Via Quattro Fontane, and secondly because they obviously moved in a social group in which Samuel felt unhappy. The attitude of social superiority shown by Collins is ironically exemplified by a remark in which he speaks of 'poor Constable', once referring to pictorial composition as 'pictur-making'.[1] Little did Collins realize that in a hundred years' time as few would have known of his own picture of 'The Villa d'Este' in the Victoria and Albert Museum as would have bothered about Constable's Suffolk dialect. Moreover, it is through Wilkie Collins, his son, that the family is best known.

[1] Quoted by Wilkie Collins in his biography of his father, *Memoirs of the Life of William Collins, Esq. R. A.* London, 1848. (N.B. the 'Esq'.)

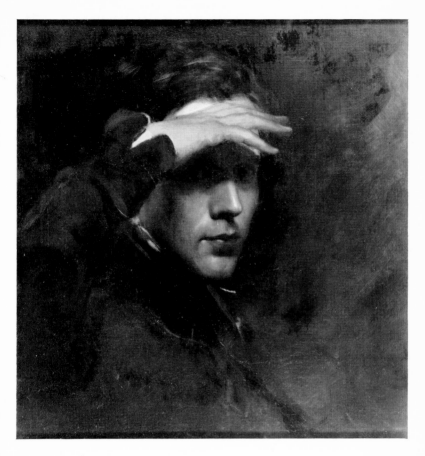

7. Self-portrait in oils, by George Richmond, 1840. *Kerrison Preston Collection*

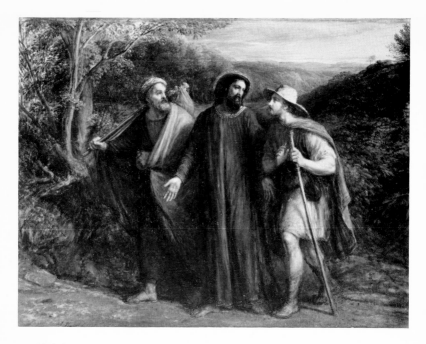

8. (*a*) 'The Journey to Emmaus' by John Linnell, 1838. *The Ashmolean Museum, Oxford*

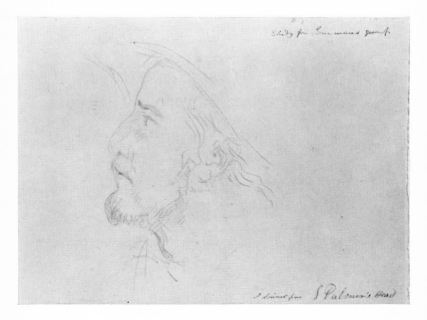

8. (*b*) Pencil sketch for head of Samuel Palmer from 'The Journey to Emmaus'. *Joan Linnell Ivimy Collection*

During the cold weather the Palmers continued to live up three flights of stairs in their one room; Samuel wearing two waistcoats lined with flannel, and two shirts, and Hannah with a cloak and boa up to the chin. They could afford no better. Samuel had had no commissions, his Grove Street house was still unlet, and his tenant in a cottage at Shoreham seemed to have defaulted also. As he had lost about £20 on the previous tenant, the situation was serious. But no one could say that they were living extravagantly. They had a halfpennyworth of chocolate for breakfast, fivepenceworth of bread and ricotta (buttermilk curds) at twopence a pound for lunch, no tea, and dinner costing between fifteen- and eighteenpence. Even allowing for changed rates of exchange, this was only a minimum; yet after the first month they both were healthy and had never been happier. In the week before Lent (17–22 February) the Palmers' luck returned. Hannah fortunately had a week's holiday thrust upon her. The famous Roman Carnival took over the city, and the mile-long Corso was barricaded from all its side streets so that she could not cross it on her way to the Vatican. Each evening riderless horses, urged on by the shouts of thousands of onlookers, and by balls of metal spikes bouncing on their quarters, used to be made to race wildly down the narrow street. Then after dusk the whole city became a masquerade. Hannah enjoyed it all: the splendid dresses of the women in the coaches draped in silk or satin; the rich draperies hanging from the windows; the costumes of those simulating bears or monkeys; the impersonations of coachmen 'dressed as women'; the sweetmeats with which they all pelted each other and the jests and buffoonery of the gay scene. Her reaction was not that of a 'puritan'.

Samuel took up his stool on the Pincian hill and made a water-colour drawing of the start of the race. Then he received a commission for a copy from John Baring for his father, Sir Thomas. So the 'Bacchic Masquers and a car covered with garlands' (Plate 5) earned him forty guineas, which must have been a godsend to the Palmers. His first viewpoint was high in the Pincian Gardens overlooking the Piazza del Popolo at the moment of the start of the race as the loose horses were about to dash down the Corso between the twin churches of S. Maria di Monte Santo and S. Maria de' Miracoli.

As for his 'Ancient Rome' (Plate 6), to which this drawing is a companion, he took up another position for drawing the foreground, in which there are the dancing figures, the Bacchic car pulled by the two bullocks, and some of his best drawing of trees and foliage. The fact that, in actuality, one cannot see as much of St. Peter's and the Tiber from the second position evidently puzzled George Richmond, who, with John Baring, visited Palmer's viewpoint to see how much Palmer had introduced on the right and left which could not, in fact, be seen. It is strange that this should have worried them; however, Richmond remarked that no one other than Turner could have done it so well. Like Turner, Palmer thought accurate topographical treatment, embracing only what could be seen from one viewpoint, did not represent a place as well as a view with objects chosen for their appropriateness. Turner always selected either by omission or by addition of objects. Before the discoveries of Daguerre which later invalidated much accurate topographical drawing, the R.A. catalogues differentiated between a 'Landscape Composition' and a 'View'. In his 'Modern Rome' Palmer made a most happy relationship between foreground and distance in the *vedute ideale* tradition.

The companion drawing (also $15\frac{3}{4}$ inches by $22\frac{1}{2}$ inches), called 'Ancient Rome', caused him more trouble. High in the sixteenth-century bell-tower of the Palace of the Senator he looked down on the Forum, with the Colosseum and S. Giovanni Laterano beyond, the Palatine hill to his right, the aqueducts of the *Campagna* in the far distance, and the snow-capped Sabine hills piercing the sky. The Campo Vaccino, as the Forum was still called, was a 'lovely lake of time', and had not yet been levelled by excavation until it had become, in Zola's words, a 'long, clean, livid trench'. All this is in Palmer's water-colour, as are all the chief monuments; the columns, grey and red granite of the Temple of Saturn, and fluted of the Temple of Vespasian, the single pillar of Phocas,[1] and the Arch of Severus with roses, oleanders, ivy, and wistaria clinging to the ancient stones. With this subject Palmer had astonishing difficulties

[1] 'Thou nameless column with the buried base!' (*Childe Harold's Pilgrimage, IV, LX.*), apostrophized by Byron, who saw it in 1817 when its base had been uncovered showing an inscription. However, for poetic reasons, he chose to ignore this.

with regard to perspective, foreground, and composition. He had to go into the Tower for the greater part of the painting of the scene, then take up a position in an alley window at a lower level, as his previous great height gave him no foreground. His expression of these difficulties appears almost to be an admission of his wish to be a 'naturalist' or topographical painter.

The view over the Forum looking east had been drawn and painted in a variety of ways many times before. In an etching, now in the Metropolitan Museum, New York, Giuseppi Vasi (1765) has successfully foreshortened the panoramic view, as Palmer did later, to include not only all the chief monuments but the distant scene as far as the Sabine hills. To do this he must also have used two viewpoints. Other artists before him had either been almost photographic in their accurate detail, or so free that they composed imaginary landscapes using well-known Roman monuments. Pannini's 'View of the Forum' (1735), in the Detroit Institute of Arts, looks east and shows all ruins and monuments accurately related to each other, whereas he also composed many *veduti ideali* in which he gathered together and juxtaposed various objects far apart. In his 'Landscape with Roman Ruins', now in the Kaiser Friedrich Museum, Berlin, the Column of Trajan appears in front of the Colosseum; a round temple, obviously meant to be the Temple of the Sibyl at Tivoli, flanks the Arch of Constantine, and in the foreground is a neat array of famous statues: the Farnese Hercules, the Dying Gaul, and so on. With equally successful results, Hubert Robert could combine the fanciful with the actual in his particular arcadia. In his 'Portico with the Statue of Marcus Aurelius', now in the Louvre, one can see the emperor on his horse, framed by the Arch of Titus and in front of the Temple of the Sibyl. The romantic detail of laundry hung out to dry on a line connecting the horse's leg and the arch adds to the fantasy. The possibilities in such scenes were limitless, and the variations within the tradition of taking liberties, although drawing from nature, endless. But Palmer sums up his difficulties to Linnell:

I was determined to get the whole of the ruins, which I believe has not been done. I got a little pencil sketch of part of it from a window, fixing the height of the horizon—then composed from it at

home as I imagined it ought to come if all of it could be seen, and then
worked the details from the tower of the Capitol where I saw every-
thing but 150 feet beneath me. I also took great pains to arrange it so
as to be a companion drawing to the Modern Rome. But then came
the grapple of having of course no foreground and the distance being
full of subject. I knew that if I did not do it at the time I should never
have courage to tackle it. I tried many experiments—suffered intensely
for two or three days, became yellow and so thin that I could pull out
my waistcoat three inches from my body—but being determined to
do it or die it came suddenly all right and I hope to exhibit it with the
other.

In replying to Palmer's letter, Linnell recommended, as he con-
sistently did, that the foreground should be drawn from life, then
the rest could be freely interpreted. But by the time Palmer received
this letter the 'Ancient Rome' would have been finished. In this
same letter Linnell does not mention the Spring exhibition at the
Royal Academy to which he had sent his portrait of Sir Robert Peel
together with four other portraits. Elizabeth Linnell makes the
only reference to the R.A., commenting favourably on Wilkie's
'Her Majesty's First Privy Council'. In the same exhibition Turner
showed his 'Modern Italy' and 'Ancient Italy, Ovid banished from
Rome'.

In the exhibition at Rome at the same time six of Palmer's
water-colours, including one of 'Ponte Rotto'[1] and another of
'Rome from the Borghese Gardens',[2] were commented upon
favourably. Penry Williams told George Richmond he thought they
had a great deal of 'go'—a phrase that Samuel did not understand,
despite its colloquial usage having been common for at least ten
years. Other drawings were 'Rome from Via Sistina'[3] with St.
Peter's dome in the distance, a sunset overlaid with terracotta strips
of horizontal clouds and the usual peasants and donkey in the fore-
ground. And 'Rome and the Vatican from the Western Hills'.

[1] 'Ponte Rotto, Temple of Vesta and the Palace of the Caesars, Rome.' Exhibited
in the Royal Academy, 1842. I have been unable to trace this drawing.

[2] Stone pines in the foreground; Ionic columns of Porta Flaminia in the middle
distance; St. Peter's and Castel S. Angelo in far distance, water-colour with gouache
and gum over pencil on buff paper, 16¾ inches by 22½ inches. Victoria and Albert
Museum.

[3] Water-colour over pencil, 10¾ inches by 14⅞ inches. Victoria and Albert Museum.

Pilgrims resting on the last stage of their journey.[1] He also finished a drawing entitled 'A Roman Street' (R.A. 1841), which was Via dei Coronari with Raphael's house, which is still there. It would have been interesting for us to have had another drawing by him of the outside of Raphael's studio, which was in a small street on the approach to the basilica of St. Peter's. Although the studio was in perfect condition, it was sacrified to make way for the processional approach designed by Fascist architects and completed in 1950. So today there is no longer any surprise as the basilica comes into view, and as a result the Dome appears even squatter than it did to Hannah, who remarked that it had not the majesty of St. Paul's, London. With an innate sense of architectural proportions she realized that Carlo Maderno's façade is possibly too long in relation to its height, and that the length of the nave does obscure the view of the dome when one is in the piazza. She certainly must have looked at it a number of times, for by the end of March she had completed thirteen of the drawings for her father of the Raphael Loggia.

Then, after working all through Lent, she was exhausted:

I have finished 22 of the Bible subjects which I selected as the very cream of the Loggia; a great many of the others are dreadfully faded and have not much interest in them.[2] I expect in a short time to finish six more which are prepared. I found the Easter ceremonies just came in time. I was getting rather poorly with the constant mental application to which I was unused at home, as at home I always had change of employment. It is very fatiguing to copy. From the lofty ceilings where the things are mostly in the dark some of the frescoes are placed over large windows so that when you look up the glare of the light from the windows entirely obscures the picture.

Although she admitted she had enjoyed copying the loggias, as she had discovered thereby many of the beauties of the frescoes, there can be no doubt it seriously taxed her strength, and furthermore, according to A. H. Palmer, ruined her eyesight.[3]

The Easter ceremonies provided a welcome break in the work.

[1] Water-colour, gouache, and ink on buff paper, sky very faded, foxed, 20 inches by 28 inches. Fitzwilliam Museum, Cambridge.

[2] Exposure to the air, with changes of temperature, had damaged and obliterated many of them.

[3] But in his dislike of the Linnell family he always exaggerated.

Samuel writes to his cousin, Samuel Giles, in enthusiastic terms which he would never have used to John Linnell. Hannah and he had been

several times within a yard of the Pope. We saw him wash the feet of the thirteen priests (whom he afterwards waits on at dinner girding himself with a napkin), and after singing mass, bless the immense assembled multitudes from the façade of St. Peter's. This is a sublime spectacle—thousands of country people in their picturesque costumes, beating their breasts, holding out strings of beads, and awaiting, in breathless silence, the great benediction. When the Pope appears, all is hushed. He spreads out his arms over the people and blesses them; and then, all in a moment, the great guns of St. Angelo fire, the martial bands distributed over the piazza, strike up, and the bells of the city, which are silenced through Passion Week, ring out a peal.

But he did not think the grandest ceremonials were equal to those in an English cathedral, and he was especially disappointed by some of the music in St. Peter's, where the leader of the choir could be seen energetically beating time and periodically shouting, 'piano! piano!' rather 'too forte'.

However, the illumination of the interior of the basilica by a sixty-foot cross, outlined with lamps and suspended from the vault of the nave, was memorable. And at night, from the Pincian Hill the horizontal and vertical lines of moving flames on every frieze, cornice, and pillar of the dome was magical. So by day was the view from the top of the Dome to little Tommy Richmond, who was carried up the steps on the back of his father's friend, Dr. Manning: the future Cardinal supporting the future Canon of the Church of England.

After dark on Easter Monday the Palmers sat on the banks of the Tiber with thousands of others watching *La Girandola*, the magnificent firework display from Castel Sant Angelo. Processions of boats lit by torches passed up and down the river, golden with reflections. All was silent until the first cannon,[1] roaring from the battlements, shook the air, and *La Girandola*, the gigantic Catherine wheel of revolving discs and rockets, sprayed the angel topping the tower.

[1] '*Allora la Mole Adriano rimbombo pei replicati colpidi cannone. . .*' *Diario di Roma*, 17 April 1838.

So St. Michael, with broad, expanded wings, seemed to float over the tower in a mass of flame.

As the warmer sun blazed in May, and malaria infiltrated from the *campagna*, the Palmers wisely decided to go to Naples, which from all accounts was 'an earthly paradise'.

Naples, Pompeii, and Corpo di Cava

This region, surely, is not of the earth,
Was it not dropt from Heaven?[1] Not a grove
Citron or pine or cedar, not a grot
Sea-worn and mantled with the gadding vine
But breathes enchantment.

SAMUEL ROGERS, *Italy, A Poem*, 1930

O N leaving Rome they must have asked themselves one or two questions to which some of the answers seemed painful. What had they achieved since their arrival in November? Financially very little. Samuel had had only one commission, for his drawing of the Carnival, and although they had both shown pictures in the Rome exhibition, none had been sold. Hannah had completed much colouring of engravings of the Sistine Chapel and copying of the Raphael Loggia and the 'School of Athens', but she had by no means finished her father's commissions. Whom had they met who might be future patrons? No one except John Baring, as a result of the letter of introduction from George Richmond. What was the reason for the apparent reticence on Richmond's part in introducing Samuel to other patrons? In A. H. Palmer's opinion it was because Richmond lacked the 'moral courage' to give him an entrée to his rich friends, as Samuel's appearance was odd and his manner awkward. This is a just estimate of Samuel's social graces, but a churlish comment on Richmond's friendship. Helped by his accomplished and delightful

[1] Sannazzaro, *Arcadia*, 'Un pezzo di cielo caduto in terra'.

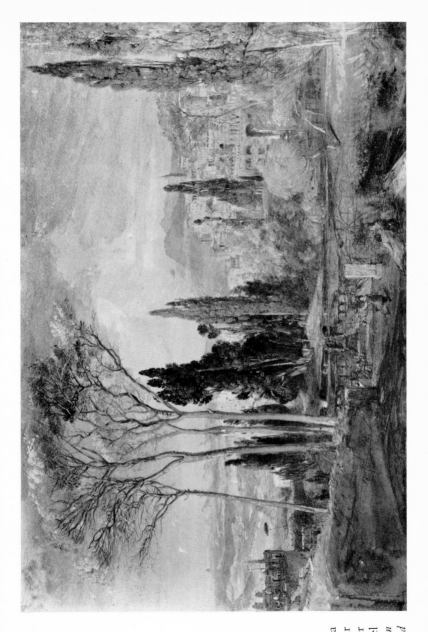

9. 'View from Villa d'Este', water-colour with body-colour over pencil, by Samuel Palmer. *The Ashmolean Museum, Oxford*

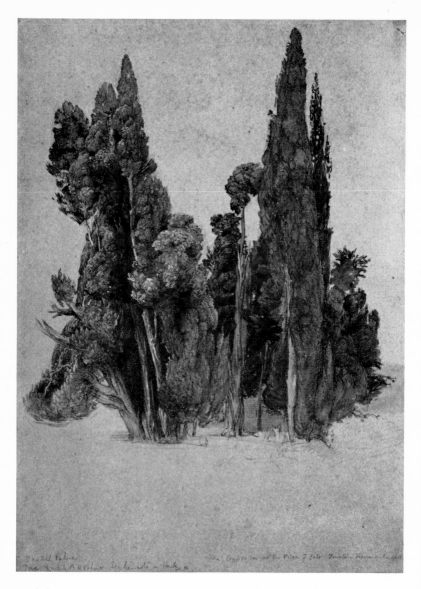

10. 'The Cypresses at Villa d'Este', water-colour with black chalk and gouache, by Samuel Palmer. *Paul Mellon Collection*

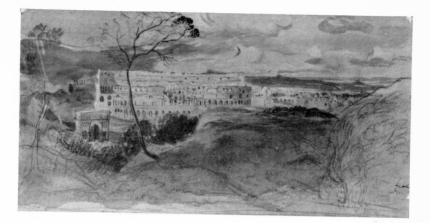

11. (*a*) 'The Colosseum and the Alban Mount', preliminary water-colour on buff paper, by Samuel Palmer. *Herbert Powell Collection, National Art Collections Fund*

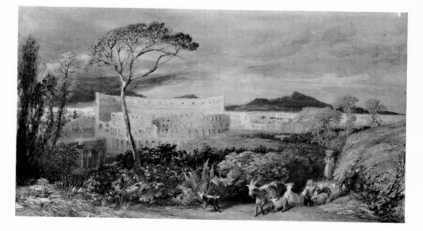

11. (*b*) 'The Colosseum and the Alban Mount', water-colour, heightened with body-colour over black chalk, by Samuel Palmer. *The Ashmolean Museum, Oxford*

12. 'How to avoid the glare when looking up in the Sistine Chapel', pen sketch in letter from John Linnell to Hannah Palmer, 24 January 1839

wife, Richmond avoided the socially suicidal contempt for amenities and social contacts shown by the Palmers; but from youth to old age there was a deep affection for Palmer which survived Richmond's becoming a successful society portrait painter. In 1884, after Samuel's and his own wife's death, he wrote that 'among all the many mercies of my now long life, the friendship of Samuel Palmer and then this early love were, to my poor seeming, the greatest that ever were given me'. No, it was not lack of moral courage, but a realization that Samuel would not be happy in the company of the people whom he might meet at dinner with Lord Farrer, or at Baron Bunsen's parties at the Prussian Legation, where, according to Sir William Richmond, 'all the celebrated men and women of the day were wont to congregate—artists, diplomatists, writers, budding politicians and statesmen came into close contact in a coterie, which, if numerically small, was intellectually great'.[1]

Among these people were patrons of the arts, who on their return to England required views of Rome and the *campagna* to remind them of their Italian visit. This is what the traditional water-colourists had provided, some with topographical accuracy, others by conveying the atmosphere of the place. There was infinite variety, from John Robert Cozens's restrained grandeur to Samuel Prout's detailed picturesque or Turner's radiance of reflected lights. But in their several ways they continued a tradition of painting Italian scenes which had started early in the eighteenth century. Alexander Cozens's monochromes, Richard Wilson's austere classical designs, William Pars's cool landscapes with figures, and Francis Towne's linearly stupendous ruins each provided recognizable landscapes, although they might not be such set views as those of Paul Sandby at home. Nor did they all use transparent washes on granular paper in the water-colour tradition—some thought opaque pigment was more suitable for Italian colouring, whereas the luminosity obtained by the paper exposed was better for portraying English lights and clouds. Turner certainly used body-colour on grey or brown paper; Richard Wilson's water-colours were often in black chalk on grey paper also, not in the accepted water-colour medium, the result being, according to Laurence Binyon, 'some sort

[1] *Richmond Papers*, ed. A. M. W. Stirling, London, 1926.

of distemper'.[1] Palmer also used body-colour pigments mixed with Chinese white and cadmium to get warm tints in much of his Italian work, and in doing so he was adopting the Continental tradition of water-colour used by Bonington. Perhaps he was influenced by Ackermann's experimental improvements in the manufacture of water-colours, which were described by Thackeray in 1840:

a permanent white of great brightness which will be very acceptable to the professors of water-colour painting, as many of the most distinguished among them are at length allowed by custom to avail themselves ad libitum of its vigorous aid. Heretofore, the *cognosc* would not tolerate upon the finest coloured drawing a single speck of this bright pigment—no, not even to the tipping of a skimming sea-gull's wing. Now, the daring, dashing emulators of *oil*, splash it about at will, and most effectively.[2]

In 1834 Winsor and Newton had produced a Chinese white made from oxide of zinc which they claimed would remain white. Palmer does not remark on his reasons for using this opaque colour, so we must assume it was his wish to realize the stronger Italian lights.

Yet, however he painted, without introductions to patrons it was impossible to sell pictures in Rome; and it is certain he did not get to know the group of artists which he describes as

on visiting terms with the gentry, who form with them here one large family of art, and from all communication with which I am as remote as a Laplander. . . . All who know us by sight, know us as nobody, and as creatures whom nobody knows . . . I dress as well— indeed better than I can afford and try not to be disgusting in any way, but there seems to be a great chasm between me and gentility— that gentility which I despise . . . Mr. Richmond has had the whole visiting circle of Rome open to him, and if he had been a landscape painter would have found the advantage of it.

This is a sad but true acknowledgement of the situation. Sad because it was exceptional for English artists in Rome not to be able to sell pictures to English people who wintered there and who

[1] *English Water-colours*, London, 1946, p. 32.
[2] *Stray Papers*, London, 1901.

patronized 'art', many of whom undoubtedly wished to recall Roman scenes. Even Lawrence was addicted to this nostalgia, for in 1828 he wrote to a young painter, then in Rome:

If the evenings are still of the same beautiful serenity which I remember, will you give one of their happiest effects to a general view from the front terrace of San Pietro in Montorio. I used often to drive up there for the delighted admiration which the grand expension of that scenery so constantly excited. It reminded me of Milton's fine description of Rome in the 'Paradise Regained' . . . Be free as air in your choice of subject, so that you employ your talents; and do not lose this spring-time of your life, which, from your present residence, will hereafter appear its happiest epoch.

Edward Lear is typical of a young painter who was in Rome in the winter of 1838, when he had fewer financial difficulties than later in life as a result of giving drawing lessons and eventually publishing his *Views of Rome and its Environs* (1841). As many visitors in those days used to sketch, rather as most Americans have cameras today, it was common for them to take lessons, irrespective of talent, water-colour drawings being the accepted medium, which was rapidly adopted by the rich middle class who also became patrons.

But the Palmers must have forgotten their lack of patrons as they travelled along the Appian Way in a *vettura*, past the blue lake of Nemi, deeply cupped in the Alban hills, to reach the piazzetta of Velletri for the first night. The next day, 29 May, still continuing along the Appian Way, they dropped down to the Pontine Marshes, along which the road went in straight, Roman fashion for twenty-five miles. As soon as they felt the sea-breezes their spirits lightened, though they were assaulted by fleas and troubled by the report of brigands. However, the former were the more potent, and they did not need the brace of loaded pistols which lay on the seat beside them. Having climbed slowly through the rocky promontory at Terracina, cut by Trajan to make the path of Via Appia easier, they spent the second night at Formia.[1] At midnight on the third day

[1] Plate 13 shows them *en route*, after they had 'entered the charming gardens of the hotel, an old villa, and looked from among the terraced vineyards over the bay to Gaeta'. Letter to George Richmond.

they reached Naples, and after a day or two found lodgings with Edward Lear and Thomas Uwins in the Hôtel de Ville de Rome, from where Samuel wrote to the Richmonds at Florence.

Friday we devoted to searching [for a room] and were amply repaid by getting a very pretty room with a balcony opening on a terrace which stands out over the Bay, with Vesuvius quite before our window. . . . We are just returned from a long walk on the Vomero and have been delighted with the beautiful views which surpass anything I have seen, and seem like dreams of Heaven. We have walked from 8 this morning till 5 tonight, and although the sun has shone with all its usual splendour, we have felt quite cool owing to continual fresh wind from the sea.

I have thought much about you and only wish you were here. I long to receive your letter and feel it quite a privilege to write being now deprived of your society. I hope you have had a nice journey with the dear children and above all, dear Mrs. Richmond I feel thankful for your kind friendship which will never be forgotten.[1]

It is interesting to compare the lives of Lear and Uwins with Palmer's up to that date. Neither of them had had a period of painting in any way comparable to Palmer's at Shoreham; but Lear, then in his middle twenties, wished to excel in topographical landscape in water-colours. He had already written many of the limericks which subsequently appeared in his *Book of Nonsense*, but he regarded these as only an amusing pastime. He was then working on his *Illustrated Excursions in Italy*, containing lithographs which later so delighted the Queen that she appointed him to give her a course of twelve drawing lessons. While in Italy from 1837 to 1840, this 'lumbering, dowdy'[2] bachelor managed to find patrons, similar to Lord Derby, his first patron. In summer he was an inveterate and adventurous traveller; in winter he gave art lessons in Rome. His passport, like Palmer's, had been signed by Lord Palmerston, whose reputation for liberal sentiments had reached even petty officials in different parts of Italy. So on one occasion Lear was arrested near Aquila by an official who, seeing Palmerston's signature, thought he had the noble lord in front of him. The Palmers met him twice

[1] Richmond MSS.
[2] Roy Murphy, *Edward Lear's Indian Journal*, London, 1953.

again on their tour, yet they remark only on his excellent flute playing, not on his water-colours or lithographs.

Thomas Uwins, who had been a friend of William Giles, Palmer's grandfather, is the classic example of a nineteenth-century artist who spent much of his time in Italy painting sentimental open-air scenes with a warm luxuriance of colour like a stage backcloth (quite unlike his sensitive work when in England), which he sent year by year to the R.A. 'Dancing the Tarantella at Naples', shown in the R.A. in 1830 and now in the Sheepshanks Collection in the Bethnal Green Museum, is typical of this work. Such a fate might have been Palmer's had he stayed in Italy, as A. H. Palmer constantly says he should have done to 'avoid Linnell's influence'. But such a *déraciné* existence was obviously fatal for an English artist, however convenient the patronage. Lear did not stay in Italy, but other painters like Penry Williams, who lived in Rome for sixty years, show the baneful influence on Northerners of those hot, clear skies and high tones.

Some writers consider that even a visit to Italy could be fatal to artists from northern Europe, declaring that Rembrandt, Delacroix, and Constable gained through not visiting that country. But although Rembrandt, for example, never visited Italy, there is no doubt, as Sir Kenneth Clark says, 'of the manner in which Rembrandt transformed his style by the study of Italian Renaissance art'.[1] In any case, to claim hypothetically that painters benefited by not visiting Italy is as illogical as the antithesis that Richard Wilson, Corot, Wilkie, and Turner would have done better to stay at home. Any initial Claudean or Italianate influences appearing in their work are quickly absorbed into their particular vision, and with advantage. Thus the cypresses of Tivoli appear in Palmer's later etchings, though they have become poplars, and the light has been translated to an English sunrise.[2] In days when all that artists could see of Renaissance painting was in galleries, auction rooms, and private collections (unless they were satisfied by prints or engravings) it must also have been stimulating for them to see original works.

After a few days the Palmers moved into rooms on the hills at

[1] *Rembrandt and the Italian Renaissance*, London, 1966.
[2] See 'The Early Ploughman', Plate 19.

the back of the city. From their balcony they could gaze at the panoramic view before them. There lay the blue sea edged by a rich plain, ringed by mountains, from Vesuvius and Monte S. Angelo on their left, along the Sorrentine promontory, to the alluring island of Capri: a perfect prospect in which sea, headland, and islands are brought together by Nature in an enchanted union. As it was not safe for Hannah to go out alone in Naples, she was either forced to make studies of this view or to copy Correggio's 'Betrothal of St. Catharine to the Infant Christ' in the museum, or to accompany Samuel, sharing his umbrella to sketch the same subjects. A. H. Palmer morosely remarks 'he was hampered by the presence of his wife', though how he could have deduced this from an examination of the correspondence it is impossible to imagine. Their expressions of happiness in each other's company are constantly restated, and the amount of work which Samuel achieved was adequate for a portfolio. Most of his colouring of drawings was done on the spot, unlike Turner, who had a phenomenal memory and who could return home to complete a water-colour after having done line drawings.

During the month of June the question of money still continued to bother Palmer. After ten months abroad they had £87. 19s., left, and he had spent his £50 of savings on the journey from London to Rome—not an excessive amount considering that they had been three or four days in Milan and Florence and a week in Paris. They had lived in Rome on the extraordinarily low figure of £40 a year each for food and lodging. But they had had extortionate additional expenses as they travelled—for passport visas at Customs: for example, £10 to enter the Kingdom of the Two Sicilies from the Papal State. And they heard tales of artists who had been compelled to pay heavy duties on their portfolios of work; even of one artist who had been unable to pay and had torn up all his work at the Custom House. But the Palmers should have known that his drawings would find a place on the English art market on their return, even though there was a glut of work from Italy during the 1830s. John Linnell had twice asked them to name a price for the drawings of the Raphael Loggia which he had commissioned from Hannah. After the first request she replied she was 'sure so far from thinking

of money' she was 'only sorry that he should think of them in terms of money', adding she considered twelve years of her work would never half cover the 'benefits and gratitude that I owe'. Likewise Samuel stated he considered a present of 'highly finished drawings of the whole Vatican a poor return' for what Linnell had taught him in Art. However, after the second request for a price to be stated, they worked out, by elaborate calculation of the time spent and the money expended on travel, etc., that the whole set of fifty-two drawings of the Loggia should cost £17. 11s. 0d. A modest sum; but it was difficult for them to arrive at a figure, and they also said they would make a point of giving Linnell the first offer of any copies by Anny of Old Masters which they wished to sell.

Among friends who afterwards bought some of Palmer's pictures was young Henry Acland, brother of Sir Dyke Acland, the politician. The Palmers write at length of his friendship and kindness. While they were in Naples, Acland had managed to obtain a berth in H.M.S. *Pembroke*, which was cruising in the Mediterranean; and during this tour he made many drawings of the places he visited, even on the plains of Troy. He was a delightful companion, to whom the Palmers, often snubbed in Rome by the English, immediately warmed. His reactions to them must have been similar to his welcome to the young Ruskin, who found himself trying to swim in the socially aristocratic waters of Christ Church, Oxford, while they were undergraduates together. But as well as these personal qualities he showed himself in his subsequent career to have been a widely educated man, to a degree to which many aspire and few achieve, eventually becoming Regius Professor of Medicine at Oxford. In these early days in Italy he was having a holiday, with the Navy as his host. On his invitation, Hannah and Samuel were rowed out in a boat to H.M.S. *Pembroke* for an afternoon's visit.[1] Samuel's reaction is unexpected in showing how much he appreciated orderliness and tidiness. The ship was like 'a model of a painter's house—all in order for action—full stores simplified by the exactest order, the cleanliness equal to any drawing room'.

[1] See a contemporary Italian *tempera* entitled 'Eruzione del 1838', of Vesuvius erupting, and a warship in the bay, flying the Union Jack; now at Arlington Court, near Barnstaple, Devon.

After about a month and a half in Naples they moved out to Pompeii. Hannah thought the journey on mules did her 'a lot of good', and when they reached the farm where they were to stay they were glad that for the first time since they left England, except for journeys, they were to be in the country. They had 'only to step off a bank' and were in the city of the dead. The cottagers with whom they stayed were a peasant family with children, the Palmers being completely isolated from their own friends. Except for a visit to Sorrento on donkeys, to get mosquito nets, they remained there for a month, until 24 July

Pompeii was not systematically excavated until the 1860s, but some of the Street of the Tombs, the main thoroughfare of the suburb outside Porta Ercolanese, was visible as today. In Palmer's water-colour 'The Street of the Tombs' the tombs by the wayside, as on Via Appia, can be seen. Its viewpoint was at the crossing of the Streets of the Tombs and the route to Vesuvius; and the Tomb of Mamia, the priestess, with its Tuscan columns and semicircular exhedra, is clearly visible in the foreground.[1]

The frescoes in some of the houses in Pompeii were then visible and made a great impression on Palmer. They 'breathed an elegance' he had seen nowhere else; 'Raphael seemed clumsy beside them':

Joints and articulation are shaken out of the pencil with all the loose hatching and improvisamento of one of Gainsborough's pollards; and tho' they are all form and design yet so far from appearing hard or cut out they would make the contours of an English historical painter seem dry and laboured. If these are the works of antique house-decorators what must Apelles have been? I carefully observed the material in those in the Museum and find the lights hatched or rather dashed on with the fullest pencil . . . reminding me of the lights in some of the choicest pictures of Richard Wilson, and very different from the quality of Raffaello's fresco and the works of the Cinquecento.

Palmer evidently knew that not one work of Apelles or other Greek masters of painting has come down to us; and his comments on

[1] Water-colour with gouache on buff paper, $11\frac{1}{2}$ inches by $16\frac{5}{8}$ inches. Victoria and Albert Museum. Also the wood-engraving for the title-page of Dickens, *Pictures from Italy*, London, 1846.

13. 'Samuel and Hannah Palmer at Gaeta', water-colour, by Samuel Palmer. *E. A. S. Barnard Collection*

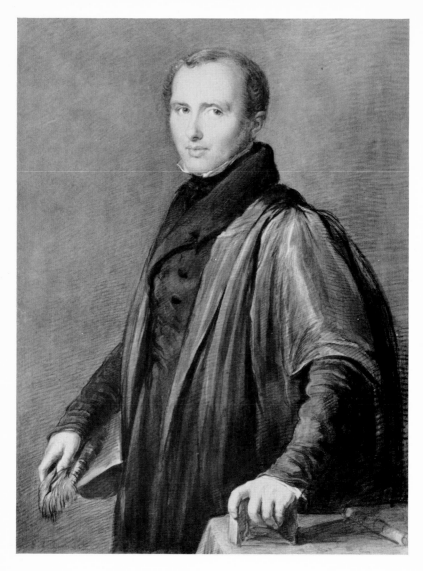

14. Portrait of the Reverend Edward Daniell, water-colour and pen, by John Linnell, 1834. *The Print Room, British Museum*

these frescoes, which were presumably executed by lesser masters, are those of a painter rather than an antiquarian—a great relief after much nineteenth-century criticism. Their miraculous preservation through nineteen centuries—the colour may well have been brighter in 1838 than it is now—is a matter for wonder.[1] Perhaps the covering of ashes from Vesuvius helped, though at the moment of the eruption in A.D. 79 there were also torrential rains which swept through the deserted houses. The exact constituents of the pigments and the substance of the frescoes may account for it; some in a special kind of tempera bound by hydrated lime, which has been scientifically examined, yet no one seems able to explain how they have survived damp and frost.

There is an astonishing variety in these frescoes: portraits and caricatures, battle and genre scenes, garden and idyllic views, sacred landscapes, still-lifes and architectural patterns. Nearly all are in ordinary middle-class houses, not in large rooms, and many are designed to create an illusion of space by architectural recession, although the artists had no rules of perspective, the walls often being divided vertically and horizontally by flowers, garlands, or foliage. Others are of tranquil and harmonious landscapes, similar even to certain Chinese painting, and undoubtedly influencing the development of English landscape gardening. In these, the single long strokes of the impressionist figures in relief, apparently dashed lightly in, with sketchy nuances of light and shade, are miraculously painted. Palmer at once delighted in the subtlety of their tonal qualities, sometimes on monochrome grounds, and the softness and delicacy of outline and colour: all of which he related to John Linnell with apt points of reference to Richard Wilson and Gainsborough. Palmer sensed the limited use of colour as in Wilson's work, and the similarity to the fiery haste with which Gainsborough painted landscapes, yet with a sureness in water-colour when painting atmospheric cloud shapes or the grace of pollards and foliage. Those 'odd scratches and marks' which, Sir Joshua Reynolds was forced to admit when referring to Gainsborough, when viewed at a

[1] The fading of the colours of the twelfth-century frescoes in St. Botolph, Hardham, near Pulborough, Sussex, which were uncovered in 1862, shows the effect of the English climate.

distance assumed form, and 'all the parts seem to drop into their proper places'. Like a fresco painter, Gainsborough used to paint standing, using a pencil with a shaft two feet long. Palmer's admiration for the ancient colony of Greeks at Pompeii was boundless. Unlike Turner, he was unable to reconcile their values with the 'body gotten science and steam coachery', as he called it, of his own century. Perhaps this is why he remained the last painter or etcher of ideal Virgilian landscape.

For nineteenth-century artists Vesuvius was an inspiring sight during an eruption, and both Joseph Wright of Derby and Turner in different years had dashed down to Naples to make drawings when the mountain was active. When the Palmers were in Pompeii, the mountain again started to rumble. Evidently to make their evening recreation of current interest they started on Bulwer Lytton's *Last Days of Pompeii* (1834). They thought little of it, recommending the Linnells only to skim through it. With the Palmers' background of Spenser, Milton, and Shakespeare it must have been light relief—the adventure story of the time; and it seems that contemporary critics also saw the author's shortcomings. 'Mr. Bulwer's philosophy is like a French palace—it is tawdry, showy, splendid', wrote Thackeray.[1]

But although Bulwer was the Linnell's M.P. at Marylebone, they had not read his book. However, Mrs. Linnell *had* read alarming accounts in *The Times* of the eruption while the Palmers were in Pompeii. She was justifiably worried, for no one can estimate the extent of any eruption, and she knew they were close. They continued to stay there, Palmer making three drawings of the crater, until the ashes falling on his paper made it too difficult and the noise from the volcano kept them awake at night. He described it with an artist's eye:

a most brilliant and highly finished white cloud issuing from the crater and softening gradually away as the wind blew it starting to the South into filmy vapour. At twilight it was of a dark brown with a focus of fire lighter than the warmish horizon. As it grew later, the fire reddened and illuminated the lower convexities of the column of smoke. For a few hours before sunrise and before midday there has

[1] *Stray Papers*, ed. Lewis Melville, London, 1901.

been an awful rumbling—like thunder but rather less pealing and more abrupt—sometimes a noise like the incessant discharge of cannon. Yesterday when we were drawing out of doors our papers were sprinkled with little black particles of ashes and we hear that some lava has overflowed toward Resina. Today it spread over us in a fiery cloud and much obscured the sunshine which was vivid a few minutes before and the sun became red as when shining through a fog. Last night the doors of our room shook when there was no wind; the house dog who lay outside our door gave a howling bark and we could hear others in the country baying the mountain. As Vesuvius is full view from our door we should stay here to get memora . . .

After receiving news of their departure from the district, Mrs. Linnell replied in generous and happy terms which entirely belie A. H. Palmer's estimate of her character.

I cannot describe the joy I felt to find you had (as in all other dangers) been preserved in safety, from the way you have been enabled to go through all you have had to do and to bear. I cannot but think that it was best that you should do as you have done and that your journey will be of the greatest use to you both . . .

The Linnells continued to write regularly of family news and events at home. Elizabeth mentioned the excitement of the children at seeing the Fair in Hyde Park and being 'quite under the showers of Rockets' celebrating the Coronation. Their appetite for illumin- ations had been whetted by their visit to the City in November. But these Coronation illuminations were far more elaborate than the previous ones, and the transparencies in gas showed even more ingenuity. The Royal Academy (the present National Gallery building) blazed with light from the whole of the portico, the pillars and pediment being 'tastefully' hung with variegated lamps; and certain shopkeepers foresaw advantages to themselves in extravagant displays. Ackermann's, the printsellers of Regent Street, showed a transparency of John Bull sitting on Magna Carta in 'the attitude of rejoicing' and surrounded by grotesque figures of Peace, Plenty and Happiness, perhaps because he had at his feet a cornucopia and a number of bags of gold coin, and above his head a wine bowl surrounded by Bacchanalian demigods. By 10.30 p.m., when Lizzy

and the children arrived in their carriage from Bayswater, Oxford Street was blocked by vehicles, carriages, wagons, and carts, and the dust from the traffic was suffocating. At the Hyde Park end it was like a fog. The fireworks in the Park were splendid, with an elaborate finale with a 'fixed piece of 14 tourbillons, 12 pots des aigrettes, 400 quarter of a pound, 450 half-pound rockets, 14 balloon mortars and two sets of serpents'.

John Linnell's own social life was among the leading artists of the day, and he wrote of a party with Joseph Severn (now back in London) at which he met Turner, Callcott[1] and Eastlake; and on another occasion of a reception at Sir Robert Peel's. After receiving Samuel's gloomy letter about his finances he encouraged him: 'You have done more than I expected, and will do more before you return. . . . It is a matter of faith with us that you will succeed.' Then he promised to be of practical assistance in arranging for his final portfolio of work to come through Customs without difficulty, by making an arrangement with the officials who deal with work coming in for Royal Academicians. Again in practical matters he offered to pay the postage of any of their letters—1s. 7d. a sheet, which was expensive. But he hoped they would be able to write once a fortnight, as they all worried at home when they did not have news for six weeks—the interval between their last letters. In addition, he had been to Grove Street to see about payment of rent by the lodgers on the second floor and he had found certain water-colours in a portfolio which had to be returned to Clarkson Stanfield, the R.A. In fact, he was helping them in every possible way by verbal encouragement with regard to work and finances, and by practical help at Grove Street.

Mrs. Linnell wrote she had had cholera, which one would have expected the Palmers to catch more easily in Naples than she in London. As usual, she had a medical remedy which she recommended to them if they should suffer from the disease: an 'outward application of laudanum and spirits of camphor to the pit of the stomach'. Once again she quotes Mrs. Starke's guide-book that there was only

[1] Callcott, unaccountably, had received a knighthood on the accession of the Queen, although he was but a disciple of Turner, who was incomparably the most eminent artist of the day.

one fountain in Naples which had safe water; but by that time the Palmers had become inured to the local water. She also continued to worry whether Hannah was eating enough. Later Hannah replied they were eating splendidly, that she was growing fat and had never been healthier—in fact, there was no need for any anxiety. Then she pointedly added: 'Had Papa withheld his consent to my marriage I am quite sure I should have been far otherwise.' In a postscript to Mrs. Linnell's letter, John Linnell suggested certain colour memos of the Pompeii frescoes might be made before they left, especially one of Achilles, which would be liked by the boys.

But by the time they received the Linnells' letter—it lay in a provincial post office for a fortnight—the Palmers were about to move, as Vesuvius was belching forth flames, smoke, and 'bright stones'.[1] So on Friday, 3 August, they hired a curricle and driver to take them to Corpo di Cava, fifteen miles inland. On the way they had a typical adventure in which Palmer acted with determination. At Cava dei Tirreni, a pleasant town in green hills,

the rest of the way being mountain road, the driver refused to go any farther and said we must have asses to carry our luggage on—during the discussion a little crowd collected which the passers-by increased, among whom were a sort of college of clergy and their driver. Not liking to have our luggage turned out at the mercy of the rabble in the dusk of the evening, I digged my eyes into the driver's, and roared into his face that if he did not go on immediately, I would not give him one grain. This had the desired effect and after telling me he would pay expense of porters if I would give them a bottle to drink, which I declined, he moved his horses convulsively about a little and went on. It was all a trick for the road was excellent and not very steep. I had in my pocket the order I sent to the man specifying the place distinctly, which I spread out before his discomforted vision. We walked all the rest of the way behind fearing lest he should contrive an accident like Mr. Weller's with the voters. While the above discussion was 'waxing fast and furious' four great dogs infected with the spirit of combat began an encounter close to Anny's legs to her no small discomforture.

[1] He made a series of water-colour sketches of the mountain in eruption. See *Life and Letters*, p. 70.

Eventually they arrived at a small inn at Corpo di Cava, over-
looking a dark ravine with a torrent, and a Benedictine monastery
hanging on a rocky hill not far off—'as fine a subject as Poussin
ever chose'. They lived well—raw ham, eggs, fruit, coffee and goats'
milk for breakfast—on 2s. 4d. a day for board and lodging. Soon the
mountain air and the Virgilian setting combined to make the next
two months possibly the happiest of their lives. Unlike the farmers
in the *Georgics*, the Palmers were aware of their happiness in their
daily work amid festoons of vines, fields of lupins grown for cattle,
and the inevitable light grey oxen as mentioned by Theocritus and
Virgil. Far from crowded cities, *genii loci* divulged secrets which they
were quick to hear. Like Virgil, they found that the Arcadian scene
was generous in the spirit which it breathed amid these farmlands;
and the Palmers did some of their best work there.

Also while in Corpo di Cava Palmer came to realize such dis-
coveries as the depth of tone of Titian and Domenichino even when
in 'the bright key of nature'. But he sensed the dangers in the use
of too much yellow, unless it was used in relation to white in 'its
proper place on the scale' in foregrounds. He also learned how deep
greens may be introduced into a 'more comprehensive scale of
harmony than that which has so often obliged artists to turn them
into brown',[1] and delighted in the 'tints and blooms' of the middle
distance of Turner's 'Apollo and Daphne', that Claude-like evocation
of the Roman *campagna* (R.A., 1837), inspired by the story from the
Metamorphoses, Book I, of Apollo and Daphne. It has a serenity about
it, despite the fire of Apollo's love and Daphne's fear as expressed
by Ovid. The painting stayed in Palmer's mind over the years,
although it was a mystery to him how it was achieved. In fact, he
thought that like Paganini's violin playing, no one would ever do
the like. Above all, at Corpo, he said he had gained the ability to see
a completed picture with figures, foregrounds, and arrangement of
colour when he sat down in front of a subject.

On 16 September, Samuel wrote to the Richmonds in Florence
that he was doing his best 'not merely by blind copying of nature,
but by studying art in nature & endeavouring to get from that

[1] See 'La Vocatella', water-colour with gouache over pencil and ink, 10½ inches by
14⅜ inches. Sheffield City Art Galleries.

great storehouse substantial principles & philosophic views . . . to show that your kindness in enabling me to make this great tour was not thrown away. . . . I now see my way & think I am no longer a mere maker of sketches, but an artist.'[1]

So he seems to have been able to clear his mind of many of the problems which had beset him, and in this it was the Virgilian setting which made it possible. From the day on which Palmer found Blake printing his Virgil wood-engravings when he visited him, to the end of his life, Virgil was never far away. The Blake engravings remained in Palmer's portfolio of treasures, and Virgil's philosophy continued to be an inspiration. Palmer's love of the pastoral and the ideals of Arcadia stand naturally in antithesis to his dislike of the patterns of social life in which upper-class dandies behaved hypocritically. Arcadian air for Palmer was purer than the dehydrated atmosphere of palaces. So it was to Tityrus (who was none other than Virgil himself) that he returned in painting his last picture, and to the *Eclogues* for his last engraving, 'Opening the Fold'.

The Linnells' letters were slow to arrive at this remote spot, and often they contained undue anxieties. The Palmers must 'avoid the risk of danger as much as possible especially at sea' (referring doubtless to their visit to H.M.S. *Pembroke*). And they were not to 'go poking into small holes in little boats to see nature's rare shows, grottos . . . mere toys compared with what was to be seen outside'. Whether Linnell was thinking of the Grotta Vecchia of Posillippo or the Grotto of Sejanus, they had visited neither, nor were they dangerous. He certainly had exaggerated Mary Linnell's fears, for she wrote to Hannah in most reasonable terms: 'whatever Papa said about my fears of your starving I know not. . . I certainly thought you were getting very short of money and might be obliged to deny yourselves many things in consequence, and I wished Papa to take some means of supplying you if necessary, but I am glad you do not need it.'

On the practical side Linnell continued to be of help, going to Grove Street to collect rent—most of it taken up by repairs and expenses—and buying a box of scales, weights, and colours—three

[1] Richmond MSS.

cakes of purple-grey as requested, and eleven lead pencils (not the most expensive costing 10*s.* a dozen), which he gave to Joseph Severn to take to Rome, where drawing-paper and blacklead pencils were inferior to those in England.

Linnell realized their difficulties in getting letters back to Bayswater; 'it would be wrong for you to write more than you can do with ease: anything, half a page just to say where and how you are, when you expect to move and where to, and anything else you please'. He also gave them practical advice on how best to wrap up a portfolio of drawings to bring home. And he wrote that he had sold his Emmaus picture (Plate 8*a*)[1] in which the bearded figure on the right is a portrait of Palmer himself. After a year away from home this is perhaps the high-water mark of the relationship between Linnell and Palmer, who remarked with gratitude that he remembered much that Linnell had said to him over the years now relating to his present problems; and Linnell spared no pains to be helpful in encouragement and practical advice. But the fact that he had never been over the sea, except to the Isle of Wight, was a disadvantage in estimating the dangers of the Palmers' travelling. Much in contrast with this attitude is that of another artist whom they met at Corpo.

On 8 September, Hannah's twentieth birthday, they had not spoken any English to anyone else since they had arrived. A few days later they were joined by John Frederick ('Spanish') Lewis, whom they found an excellent companion. He was the same age as Samuel, had travelled much in Italy, and was able to advise him of the best places from which to make panoramic views—especially in Florence. (Palmer's water-colour is proof of his following this advice, in October 1839.[2]) Lewis had been in Spain during the Carlist wars—for which he gained the nickname by which the Palmers knew him—and had had water-colours of bull-fights and civil war participants lithographed. These had brought him a fame

[1] 'Christ's appearance to the two disciples journeying to Emmaus' (R.A., 1835).

[2] Reproduced *Life and Letters*, p. 206. A panorama of Florence and Val d'Arno looking over Florence to Fiesole; the Pitti Palace and Boboli Gardens in the right foreground. Very faded, especially the sky, which was originally painted in indigo. Water-colour on grey paper with specks of body-colour on buildings, 17½ inches by 23 15/16 inches. Victoria and Albert Museum, London.

similar to that which Edward Lear achieved with his lithographs of Italian scenes. Later Lewis continued to live adventurously in Italy, and before the Palmers had left Italy they heard of him in trouble with *banditti* in the Calabria, and then of his shipwreck on the way to Palermo from Naples. After a period in Cairo, sometimes staying with Thackeray,[1] and in the Middle East, Lewis returned to be President of the Water-Colour Society, to which Palmer was elected a member. One of Lewis's subsequent pictures, 'A Frank Encampment in the Desert of Mount Sinai' (1842), induced Ruskin to praise which now seems extravagant. He had 'no hesitation in ranking it among the most *wonderful* pictures in the world; nor do I believe that, since the death of Paul Veronese anything has been painted comparable to it in its own way'.[2] This praise evidently reflected contemporary opinion. Lewis's careful water-colour drawings, with minute detail, the paint often stippled on with the point of a brush (done with the help of a magnifying glass), and sometimes painted wholly in body-colour, used to fetch (like his 'Easter Day at Rome') over £750 in the 1870s.

Soon after 'Spanish' Lewis left them the Palmers moved back to Naples. But they did not stay long, for it was a dirty, noisy, and expensive city; and Samuel found it impossible to paint in the streets without enduring insolent behaviour from ruffians. So, following Linnell's advice, they soon took lodgings at Pozzuoli and the bay of Baiae in the hope of being able to find subjects for painting, especially the viewpoint which Turner used in 'The Bay of Baiae'. This painting was in the R.A. in 1823. The viewpoint is looking out to sea along the narrow bay to a lyrical far distance bathed in magical mist. In the foreground, Apollo is granting the Cumaean Sibyl her request for as many years of life as there are grains of dust in her hand. The painting has deteriorated in recent years. Before long Palmer thought the bay was the epitome of all that was beautiful and he completed a long subject from Monte Nuovo looking towards the bay of Baiae. He would have liked to have explored more of the coast, as he still doubted his ability

[1] *Journey from Cornhill to Grand Cairo*, London, 1844.
[2] *Notes on some of the Principal Pictures exhibited in the Rooms of the Royal Academy and the Society of Painters in Water-Colours*, No. 11, London, 1856.

(unlike Turner) to make a finished drawing from a sketch on his return to London. Preferring to work on the spot, he constantly kept the finished picture in mind, thereby knowing what needed emphasis. So he never 'revelled in outlines and slight sketches'. It is strange that his method of working should have been more like a Renaissance artist than one of the nineteenth century, for he seems to have prepared careful stages from the first sketch to the finished picture. Even in the eighteenth century the spontaneity of rapid brush strokes, as in Gainsborough, and the value placed by *cognoscenti* on sketches, realized an aesthetic pitch. Indeed, as Wittkower points out, it already foreshadowed romantic painters like Delacroix. But these methods were not Palmer's, who produced work neither easily nor rapidly.

The immediate contrast between the lives of Linnell and Palmer at that time is very evident in the letters which pass between them —Linnell, established in the London art world, dining with Mulready and Collins at Mr. John Sheepshanks's, their rich patron and enthusiastic collector;[1] Palmer, just married, unpatronized, with little money, doubting his ability, and therefore troubled about his future.

[1] In 1857 he gave his collection of 233 oil paintings and 289 drawings and sketches to the nation. Mulready twice painted his portrait.

Return to Rome

> How incapable those are of producing anything of
> their own, who have spent much of their time in
> making finished copies, is well known to all who are
> conversant with our art.
>
> SIR JOSHUA REYNOLDS, *Discourse*, II

> This is most false, for no one can ever Design till
> he has learn'd the language of Art by making
> Finish'd Copies both of Nature & Art . . .
>
> WILLIAM BLAKE, *Annotations to Sir Joshua Reynolds' Discourses*

O N the way back to Rome from Naples they described the
scenery as 'Domenichino-like' in woods and foregrounds,
shining with autumn colour like burnished gold. Yet there
were few Domenichino landscapes which they could have seen, and
they must have been thinking of the idyllic 'Hunt of Diana' from
the Borghese Gallery, illustrating a passage in the *Aeneid*. Before
moving off to Tivoli in the Sabine hills, they spent only two days
in Rome, during which they again saw the Richmonds, who marvel-
led at the amount of, and standard attained in, their work during
the southern trip. The Richmonds also told them that Clarkson
Stanfield, the successful Royal Academician, was in Italy, but with-
out a commission. Remarking on this in a letter to John Linnell,
Palmer expressed surprise that Stanfield, whom he always thought
of as 'rolling in riches', should be without a commission. He might
well have been surprised, for in 1838 Stanfield had received £500

each for ten seascapes which he had executed at Bowood for Lord Lansdowne.[1] In January 1838 Macready had presented him with a handsome silver salver on the completion of the diorama for the pantomime at Covent Garden. These large pictures were influenced by his scene painting for theatres, for which he was famous, a type of work abhorrent to Palmer, who, unlike mid-century critics, to whom size was often the measurement of value, came more and more to like small pictures, the delightful 'cabinet gems' of the Old Masters. In addition, Palmer's reading and philosophy flourished in a rarer air which even John Linnell had never breathed. Samuel and Hannah were able to share this more easily with her sister Lizzy than with any other member of the family.

Writing to her on 8 July, Samuel hoped they might be able to read Plato with her once again. 'Blessed also will be the mind that is imbued with Plato—would that mine were so!—the very antithesis of the literary impudence, dandyism and materialism with which most of our modern periodicals tend imperceptibly to imbue the mind. If I am ever to open a book again & not to "live a fool & die a brute" may I open once more the divine leaves of Plato in some happy Grove St. evening with you and dear Anny by my fireside—' They must have read the translation by Thomas Taylor which contains Porphyry's *Treatise on the Homeric Cave of the Nymphs* to which Palmer then referred.[2] Plato and Porphyry treat the subject slightly differently, but with basically the same meaning. The cave in *The Republic*, Book VII, has less complex sybolism than that of Porphyry. Certain prisoners, writes Plato, are fettered in a cave lit by the light of a fire behind them. They cannot turn their heads, but they see on the wall in front of them certain shadows of puppet-like figures which move. When one of the prisoners is released, and is able to ascend a long passage into the world of daylight, he realizes that what he has seen in the world of the cave is an illusion—mere passing shadows. His mind is liberated from a world of sense perception to one of thought, a world in which ideas are, as eternal and immaterial beings, lit by the sun of Truth, the intel-

[1] Gerald Reitlinger, *The Economics of Taste*, London, 1961.
[2] First published in 1788 in Taylor's translation of Proclus's *Mathematical Commentaries*. Republished separately in 1828.

ligible light which elevates the vital and intellectual energy of the soul. Although he would not be able to convince his fellow prisoners, were he to return, he knows that the sun is the symbol for the true and the good, expressed through the world of ideas, as opposed to the fantasies of the cave. This dualism of the good and the true had always been intrinsic to Palmer's conceptions, and in this instance it is further enhanced by the image of the sun, the truth, as its source. No painter was more engrossed than he in the power of light. So the vividness of the neo-platonist analogy was deep-rooted in his thought.

Porphyry's 'Cave of the Nymphs' is more complex and associates the cave with the mysteries of the Nymphs, of birth and death, though basically the same analogy. It is founded on the description in the *Odyssey*, Book XIII, of the harbour of Phorcys in Ithaca.

At the head of the harbour is a long-leafed olive tree, and near it a pleasant, shadowy cave sacred to the nymphs that are called Naiads. Therein are mixing bowls and jars of stone, and there too the bees store honey. And in the cave are long looms of stone, at which the nymphs weave webs of purple dye, a wonder to behold; and therein are also ever-flowing springs. Two doors there are to the cave, one toward the North Wind, by which men go down, but that toward the South Wind is sacred, nor do men enter thereby; it is the way of the immortals.

Porphyry's account, deriving from Plato, but based on that in Homer, has no narrative. The cave is dark and humid, its obscurity being a symbol of what the world contains in matter and occult powers. It is also beautiful, through the arrangement and order in the participation of forms put there by God, to whom it is consecrated through the Naiads. The olive planted at the top, as in Homer, is neither fortuitous nor irrational, but is the symbol of wisdom—the plant of Minerva—created divinely. The water which flows through the cave symbolizes generation, the cave being a place of habitation for souls which are just born. As in Plato, there are two openings, for souls ascending to heaven and for those holding to life. And as in Plotinus, the former course is the way to the One or Good (the Sun), the only positive reality. There are further details

in the interpretation, and the symbolism becomes complex when the bowls and urns (bodies), and the bees (souls) are taken into account. But the main imagery of the gnostic powers of the soul expressed in water is clear.

Palmer must have been introduced to the Porphyry interpretation by William Blake, whose Arlington Court tempera painting (1821) has been authoritatively interpreted in this respect by Miss Kathleen Raine.[1] The tempera combines details from both Homer and Porphyry. The nymphs with their shuttles and weaving are clearly evident, as are the twofold entrances to the cave, but, in addition, from Homer there is Odysseus symbolizing Man, who kneels with a gesture towards the sea, as he throws back the scarf (symbolizing his mortal body) to Ino. Miss Raine states that Blake had seen Taylor's translation on its first appearance (1789).[2]

The symbol of water as the generated soul, the essence of neo-platonism, fascinated Palmer, and in a practical way he found that nowhere in the world is water more finely used than at Tivoli. In 1838 the waters roared over the cascade in the gorge of the Aniane below the Temple of the Sibyl, or gushed from terrace to terrace in the Villa d'Este garden, to plummet through monumental fountains. The magnificent Renaissance terraces, conceived by Pirro Ligorio, rise one above the other precipitously. But when the Palmers saw it the gardens had become overgrown and unkempt—a wilderness compared with the original symmetrical plan. This state appealed to Palmer—did he not in after years encourage the growth of great weeds in his garden at Redhill? But in the Villa d'Este the aged and majestic cypresses still punctuated the view as one approached from the lowest part of the garden (Plate 10).[3] And that is the way to enter (not as today from above), for then one sees the series of classic vistas to the Villa, wrapped in the blue cloak of the sky,

[1] 'The Sea of Time and Space', *Journal of the Warburg and Courtauld Institutes*, Vol. XX, 1957.

[2] The painting discovered on a pantry shelf when Arlington Court, Barnstaple, was handed over to the National Trust in 1947. On the back of the painting are words written in the writing of John Linnell's father: 'James Linnell, framer, 3 Streatham Street, Bloomsbury'.

[3] Water-colour, black chalk, and gouache on blue paper, $12\frac{1}{2}$ inches by 9 inches, referred to by John Ruskin, *Modern Painters*, Vol. I, Part II, Section 6, Chapter I, London, 1846.

looking, as Hannah said, 'like a palace of Heaven'. This is what Palmer captured in his water-colour now in the Victoria and Albert Museum.[1] In the foreground, the gaily dressed peasants dancing to a flute, having piled their blue clothes on the ground; the steps and cypresses lead up to the theatric building, and on the right the distant view over the *campagna* to Rome. Another water-colour (Plate 9) has its viewpoint near the Villa looking over the gardens to the Romanesque campanile of the Duomo. For this, Palmer used body-colour over pencil (one of those excellent ones sent by Linnell), reinforced with pen and ink and heightened in gold—a favourite medium with him later in life, shell-gold being always among his pigments, as neither lemon-yellow nor madders made true gold. At Tivoli he had no chrome in his box and very little gamboge, so he most likely relied on cadmiums and raw sienna. He was very conscious of the golden splendour of the Italian sun. 'A first-rate Claude sunset', he wrote from Tivoli, 'in which the golden horizon melting upward into a delicate azure little lighter than itself. Turning my back on it, I saw a superbly rich temple from which rills a light cascade, glittering like living gold.' He then remarked on the tonal difficulties of painting Italian lights: as 'the plenitude of light gives a coolness of shadow and a gloss of reflection' which is unknown in England. Throughout his tour of Italy the cool transparency of chequered shades stimulated Palmer and was one of his chief joys. His last letter from Italy to Bayswater shows his passionate regret at leaving these lights for a northern climate. Back in Tivoli he once again avers that no one but Turner can achieve this quality of Italian light, as he makes shadows and reflected lights much lighter than in nature, finding it impossible to obtain the clarity and lustre of shade and reflection if he made them of the true darkness relatively to the lights. Palmer says he has tried it in the natural tonal proportion and has not been able to accomplish it, for

at Naples even the lowest part of the sky, where illuminated figures or buildings come against it, is a very deep middle tint, and gets most lustrous and glowing in itself. I am inclined to think that the gorgeous, deep-toned effects of Titian which to our English eyes

[1] Water-colour with gouache, 10¾ inches by 14⅞ inches, reproduced in *Life and Letters*, p. 60.

seem like twilight are meant for Italian midday or afternoon. 'I strive all gentle means to try' by keeping my shadows tender, cool and neutral; and keeping the backgrounds broad and delicate. When I first came to Rome I tried one or two drawings with the azure nearly as dark as in nature, but as the Italian sky is as remarkable for lustre as for depth, found it would not do. I find ultramarine, lightly and delicately used, the only thing that comes near it.

This is a partial restatement of the technique which he had realized in 1824 when he had noted in his sketch-book a remark of William Blake's that a tint 'equivalent to a shadow is made by the outlines of many little forms in one mass', after which the light shines on an unbroken mass, such as flesh, near it.

It was the Impressionists later who showed the colour in shadows, perhaps capturing that quality from the antique paintings which Palmer had seen on the walls at Pompeii. But it was Turner, as Palmer noted, who exploited this light tonality, largely through his use of water-colour techniques even in oil painting. In his Italian period shadows may be inflamed or flaxen, and trees and people cerulean. Despite his visit to Italy and the thousands of drawings he made there, Turner's work becomes less classical in feeling, and Palmer's more. But this did not stop his appreciation of Turner who in the 1830s was somewhat out of favour. Their passion for light, and the raising of the whole key of colour linked them in sympathy ever since that day in 1819 when Palmer had stood spellbound at the R.A. in front of Turner's 'Orange Merchantman', the seascape with the masted ship heeling over and going to pieces at the entrance to the Meuse, the dark turbulent sea in the foreground changing to the flaming colours of sky and distance. This picture was fixed in his memory over thirty years later when Palmer said he still admired it, being himself 'by nature a lover of smudginess'.[1]

Palmer's studies of the Villa d'Este cypresses are essentially classical, and as evocative in their way as those of Fragonard or Hubert Robert in the same setting. Referring to these drawings of Palmer's, Ruskin thought 'his studies of foreign foliage especially are beyond all praise for care and fulness. I have never seen', he added, 'a stone-pine or cypress drawn except by him; and his feeling

[1] Letter to Mrs. Robinson (formerly Miss Julia Richmond), December 1872.

15. 'Below Papigno', water-colour with gouache, by Hannah Palmer, 1839. *Joan Linnell Ivimy Collection*

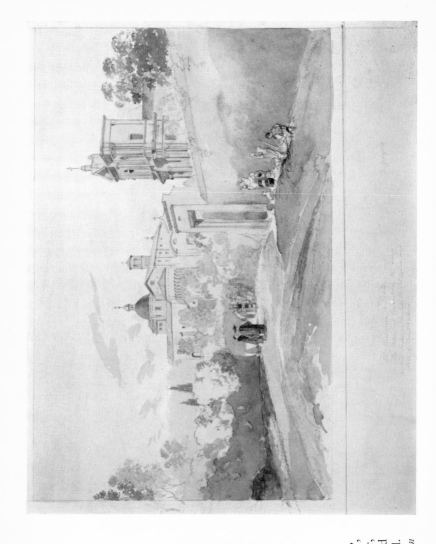

16. 'View in Rome',
pencil and water-colour,
by Samuel Palmer and
inscribed in his hand.
Carlos Peacock Collection

is as pure and grand as his fidelity is exemplary.' Another version of the cypresses appears later as a woodcut-engraving in Dickens's *Letters from Italy*, 1846; again they appear, though slightly altered, in his etching, 'The Early Ploughman', 1868.

The first of the two Tivoli water-colours, looking up to the Villa, is especially happy in his treatment of the foreground, with its Claude-like figures dancing; in the second the figures seem to become lost in the darker shadows of the foreground. The former painting might almost have been the result of Linnell's advice in a letter arriving in the middle of November, if we did not know that the foreground had been unaltered from nature. Linnell wrote that there was no doubt that Palmer 'composed too much', advising him to lay an emphasis on the beautiful, leaving agreeable blanks or breadths where the objectionable matter came. If he thought a foreground in one place was applicable to a sketch made in another, then he should make separate studies; but not marry them on the spot. If Palmer felt otherwise, he should not mind what Linnell said, as he only mentioned it as something Palmer should be careful to avoid doing on the spot for fear of injuring the veracity of a drawing from nature. The remark was of most consequence when beginning with beautiful far and middle distances; for if he started with a foreground he could then insert distances from nature without much danger of injury, as in that case he would make them sufficiently subordinate. Whereas if his drawing was elaborated in everything but a foreground, Palmer would most likely have exhausted all his strength and colour, and in parts it would be better to make a separate drawing for which any foreground and figures might be good. Then, in another drawing, he could put them together. Therefore he should take care; for though complete subjects might be more like a collection of pictures to look at and reckon upon, they would not yield so much in the long run as separate studies. Linnell also advised him to get as many figures as possible; then if they were near some bit of ruin or with some landscape behind them, he was sure to be able to make a picture, by finishing the figures first, and adding as much or little of what he saw beyond. By this method he would have the background and figures relatively true, besides completing a study applicable to other backgrounds.

Palmer was grateful to Linnell for the advice, replying that when-ever he had added anything to a subject it had been only what the first impression of that subject suggested. In consequence, he had been enabled to complete his drawing consistently, instead of having to change his foregrounds about.[1] In fact, he had not added to nature on the spot, therefore he should bring back more valuable sketches than those from his Welsh tour. He admitted difficulty with figures, especially with figures as large as in Collins's subjects, saying he leant towards the treatment of Claude, where the figures are ad-juncts to the landscape. (He could have chosen a better example than Claude's figures, which are sometimes feeble.) Palmer went on to say he was making efforts in drawing animals, especially the superb Roman oxen;[2] and that after a day's drawing from nature he could draw them tolerably well from memory.

But he thought the price of models was expensive at Rome,[3] and he would not be able to afford them. Once again he mentioned the disappointments of patronage, of how Sir Henry Russell, to whom George Richmond had recently given him an introduction, had stocked up with old masters, rather than buying contemporary works. But he hoped the Rome exhibition in the spring would be a possible source of patronage, especially as the Dukes of Sutherland and Devonshire were in Rome.[4]

Tivoli was a most worthwhile part of their tour, and Palmer realized if he could get a good stock of figures in Rome he would have completed an ordered course of study which would give him a sure footing for the future. 'Like St. Dunstan's steeple,' he says, 'if we stand now we shall stand for ever.'[5] But by the end of December it was too cold to be working out of doors, and despite wearing two pairs of stockings, an 'Indian rubbercloak' (macintosh), and one of Hannah's flannel petticoats, concealed, he could scarcely hold a

[1] The sketch and the finished drawing of 'The Colosseum and the Alban Mount' together show his method of inserting a foreground last (Plates 11*a* and *b*).

[2] These appear in his etching 'The Early Ploughman' (Plate 19).

[3] 2*s*. 2*d*. for four hours: really very cheap.

[4] William, sixth Duke of Devonshire (1790–1858), at different times patronized William Hunt, John Gibson, and Landseer, so there may have been hope for Palmer.

[5] St. Dunstan-in-the-East, Wren's tower with ribbed, arched spire survives, the church partly destroyed in 1941 by enemy action.

brush. So they travelled down past the aged olive trees, back to Rome for Christmas.

Through George Richmond they received an invitation to a party on New Year's Day at the Prince Torlonia's. It was held in honour of the twenty-three-year-old Grand Duke of Russia, who, according to Richmond, had 'a forehead retreating like all royal ones'. Despite Hannah wearing a new dress, Samuel did not meet the Dukes of Devonshire and Sutherland nor the Grand Duke, so no further patrons were forthcoming.

Soon after their arrival in the city they received an astonishing letter of about four thousand words from John Linnell, no other member of the family contributing, as had been the custom in every letter previously. Like many who have not suffered the formal disciplines of education, Linnell carried through life violent *idées fixes* which he wished to impose on others. His two strongest were conservatism in outlook and hierarchical wickedness in churches. These phobias may be admissible in themselves, but not if foisted on to friends with such an emotional impact as to deaden the sensitive points of daily communication and mutual understanding. It was exactly a year since Hannah and Samuel had received one of these letters, and this second one was stated in even stronger terms than the first. The opening paragraph sets the dyspeptic tone of his ill-digested attitude: 'Affairs at Bayswater are in that beautiful Tory-like stagnant state which for want of wholesome agitation subsides into condensed putrifaction and corruption; unless some fermentation takes place and preserves us from stinking, and turning us at least into vinegar, we shall all be as corrupt as your bottle of egg mixture or as the late rotten Boroughs.'

Then in vinegar phrases he rated Samuel for not telling him of Hannah's illness in Rome as a result of the stove in her room. (Almost forgotten after a year?) He suggested they were deceitful, and that in future it might be difficult even to believe their expressions of happiness in each other's company. Then he regurgitated his hatred of secrecy and 'freemasonry', and his detestation of 'pious fraud'. For another thousand words he attacked Palmer's religious views and indeed the dogmas of all Christian churches and sects; asserting that the only true religion was by reference to

the gospels themselves, and even expressing the hope that Hannah, his 'beloved eldest child', had not absorbed Palmer's views too deeply. This was followed by a brief account of John Varley bringing a horoscope[1] he had made for Hannah's birth, and a warning that Varley thought she ought to be careful about her health in the near future (with another reference by Linnell to the coal stove). Then Linnell offered them money for better lodgings, in order that her health might not be jeopardized. The whole letter naturally provided a readily combustible fuel for lighting A. H. Palmer's hatred afresh; and it is certainly incomprehensible how Linnell could have imagined that after such a letter their relationship would remain unscarred by the heat of his convictions.

Their reply showed miraculous self-control and long-suffering. Palmer again averred he did not tell the Linnells of Hannah's illness because there was no danger to her life, and it would have caused them unnecessary anxiety. As to religious differences, he writes: 'I know distinctly the shape and boundaries of some few theological doctrines which I have ventured to investigate and have been led solemnly, sincerely and stedfastly to embrace, and I think that these opinions do not in the least interfere with a cordial, honest and affectionate intercourse with your family.' Then he rightly told Linnell that his suspicions tended to shut the heart and chill the affections.

It would have been difficult to accept financial help after this, so they thanked him for offering to defray expenses, which they had not then the occasion to incur. In truth they had only £16 left, and had to send to John Giles, who managed Palmer's affairs, for £40. But Hannah told her father that if he wished her to continue with the Loggia subjects he would have to pay for a coach to take her to the Vatican, although she would walk back. For some weeks after Christmas both the Sistine Chapel and the Loggia were closed, so fortunately the problem did not immediately arise, though it set back her schedule. At about this time Linnell enthusiastically mentioned the discoveries of Louis Daguerre in Paris, which eventually invalidated much of the reproducing of Old Master by copying.

[1] Reproduced in Adrian Bury, *John Varley of the 'Old Society'*, Leigh-on-Sea, 1946 Plate 77).

Daguerre did not put out his subscription list until August 1838, and then he had little support. Indeed, he had discovered a means of recording on a plate, by the use of mercury, images produced by a camera obscura, leaving an imprint in perfect graduation of tones from black to white. More important, he had found a means of fixing them by using a solution of salt and water to dissolve the silver iodide. So he could obtain a perfect image in between three and thirty minutes. Not until October 1839 were there public demonstrations and exhibitions in England, so Linnell was well up to date. The miracle of the photograph profoundly affected artists. The very claim of the daguerrotype that it was not merely an instrument which served to draw Nature, but was a chemical process which gave Nature the power to reproduce herself, was in itself sufficiently startling. But some years later, when Linnell's son, William, was in Rome, he received a parody verse from his father which showed how John Linnell's attitude to photography had changed:

> Send no more photos send no more,
> They were deceivers ever,
> Fading at last if not before
> And satisfying never.

In January 1838 and the succeeding months Linnell was torn between his wish to have the Loggia work and the colouring of the Michelangelo engravings completed and his fear that Hannah's health might suffer if she worked too hard. So he constantly mentioned he would pay for better lodgings, or reimburse them for transport to the Sistine Chapel. But for the moment the problem did not arise, as they could not get permission to work in the Vatican. Their old friends in Rome, John Gibson, Penry Williams, and Thomas Dessoulavy, continued to be hospitable and kind. 'Spanish' Lewis, back after being shipwrecked, showed them his sketches, and the Richmonds entertained them every Sunday evening in their house on the Tarpeian Rock. The Palmers were busy with preparations for the Rome exhibition, where Samuel's two pictures 'Ancient Rome' and 'Modern Rome' were hung in an excellent position on the line. Also accepted was Hannah's water-

colour, 'Twilight at Pompeii', 'looking up one of the solemn streets with the moon just rising over the fine mountains of lava and a bat wheeling his drowsy flight over the foreground: a few goats and a shepherd winding up a path'.

Her father was delighted by accounts of her improvement as an artist, which must have been rapid, as on her return she had five works accepted for the R.A., including the Pompeii water-colour. Linnell advised her to draw all the figures she could out of doors, possibly in some sunny sequestered garden. He recommended that for figures in a landscape she should choose a light and shade which was striking and vivid at a distance, as the figures would relive by such qualities, especially if the shapes of the lights were picturesque in every point. If a face was in shadow (Plate 4*b*), it should be well lighted by reflection, so that the light showed the action of the figure as far as possible. These he thought were the qualities which were particularly requisite in figures introduced into landscape, and always distinguished the figures of a landscape painter from those introduced into a landscape by a figure painter who did not paint landscape. But the treatment should depend chiefly upon the expression of the subject in effect and colour; and that should rule the figures. Surprisingly, Linnell then declared that Giulio Romano showed supreme qualities of vividness and picturesqueness, as well as a choice arrangement of light seen with a poetic imagination, 'straining nature through his mental sieve till everything mean and vulgar was excluded'. This is but a restatement of Reynolds's estimate that Giulio Romano had true poetical genius, 'perhaps in a higher degree than any other painter whatever'.[1] Linnell must have based his judgement on the works of Giulio at Hampton Court ('Nero making music while Rome burned')—then in a poor state. In consequence of his eulogy, the Palmers may have paused to observe more carefully the stormy frescoes in the Sala di Costantino as they passed to the Stanze.

In addition, Linnell gave Palmer practical advice, quoting Cennino Cennini's *Il Libro dell'Arte*, (*c.* 1390), which he had seen at Callcott's. A yolk of egg rather than glue should be used in grinding colours. If the yolk was mixed with the colours in equal quantities,

[1] Notes on Fresnoy's *Painting* (Note LIV).

then spread out thin on the palette it would work up again easily with water, especially if a little sugar were added. '*La seconda tenpera sia proprio rossume d'uovo*', as Cennini advised. But Palmer would not have seen the book, which was not translated into English until 1844. Had he known during the Shoreham period he might have tried this method, rather than covering his water-colours with a surface of glue which now is cracking so badly that the water-colours cannot be moved without damage.[1] He once had had an accident with a bottle of egg yolk which exploded in his pocket! Linnell remembered the incident, warning him that he would be unpopular in Rome if it were to occur again.

He also suggested they should make studies of some of the heads in the ceiling of the Raphael Loggia, as they might be valuable on their return to England. But the greatest value to him was undoubtedly a set of complete drawings of the Loggia, which would be worth ten times an incomplete set. So he recommended how it might be achieved: a German artist might be employed to assist in the copying, Palmer might work for a week at it, and a coach should take Hannah to and from the Vatican. Finally he advised an extraordinary shield which she might wear to avoid glare when looking at a fresco alongside a window (Plate 12). Palmer or she was to make this contraption from tin or board, then she should hang it on her nose by a ribbon round her head. Or, failing that, Linnell proposed she wear a large poke bonnet, drawing out like a telescope, which in his sketch looks like a reversed version of Edward Lear's 'Young Lady of Dorking, Who bought a large bonnet for walking'.

If Linnell had stuck to such practical matters with regard to painting, all would have been well; but on 6 January he wrote a complete letter in which he, his wife, and even Lizzy brought the strongest pressure to bear on the Palmers to return from Italy before the next winter. Palmer, said Linnell, had a conspiracy with Hannah to stay, had 'ice near his heart' with regard to Hannah's family, and had 'inveigled' her. Such arguments as the deterioration in Mrs. Linnell's health and her loneliness if Hannah should be absent any

[1] 'Learned that the way to fix chalk drawings is to boil leather cuttings and hold the drawing over the steam.' George Richmond, *Diary*, Wednesday, 15 November 1837.

longer, that her grandfather might die before Hannah returned, and that Lizzy would pine, culminated in the statement that Linnell would 'lose all faith' in Palmer if he should decide to stay. The whole sentimental gamut, registered on a vox humana with tremulant, is directed at them, as well as muted trumpet threats that Palmer must return to look after his property in Grove Street, or that he would not benefit in the English art world if he remained longer. Mrs. Linnell could hardly have said she was lonely, with eight children; and usually John Linnell was not apparently so solicitous of her health. It is only too evident both were possessive, neither realizing that when a daughter marries she is in a sense 'lost' to her parents— that the relationship obviously can never be the same again.

Once again Palmer replied with restraint, although he found it difficult to take Linnell's accusations lightly. He says he first read the letter in a *trattoria* while he was having dinner, and such epithets as 'conspiracy', 'inveigle' or 'ice round the heart' nearly choked him when he tried to swallow them together with a plate of *timballo di gnocchi*. Nor did they sit very well after coffee. Then he reassured Linnell they did not anticipate staying another winter in Italy, and that as soon as the work in the Sistine Chapel and the Loggia was finished, they would make their way home via Florence. At the moment it was too cold for Hannah to work in the Sistine Chapel, even if they had permission, which after endless bureaucratic delays they had failed to achieve.

With regard to the studies of heads in the ceilings of the Loggia, Palmer was doubtful whether they would be of much value, as the frescoes not being by Raphael himself did not always bear too close inspection, and in any case to draw them accurately would require a scaffold. (Linnell subsequently disagreed with this view, although he had never seen the originals.) But no effort would be spared towards the completion of the Loggia work, and the colouring of the remaining prints of the Michelangelos in the ceiling of the Sistine Chapel.

In the final paragraph of his letter, Palmer mentioned the virtues of Milton's *Of Education*. It is difficult to believe he did not do this deliberately as an indirect reference to Linnell's fiery temperament. During the course of recommendations for education

in this serene and optimistic tract, Milton cites the beauties of music, which 'if wise men and prophets be not extremely out, have a great power over the dispositions and manners, to smoothe and make them gentle from rustic harshness and distempered passions'. No one was more in need of the influence of music than Linnell when he took pen in hand. However, the reference to Milton was not missed by Linnell, who took it up in a subsequent letter. 'Poor Milton', he wrote, 'what a silly, weak man you would make of him in your beautiful Johnsonian style. How can I expect to escape when so Divine a man as Milton is constantly endeavoured to be proved a knave or a fool, or at best an inspired Idiot, because, forsooth, he hated all forms and institutions which are debasing and corrupting to human nature, and had the courage to avow it?' Then Linnell goes on to say that no one could appreciate Milton's poetry who was not in agreement with his political views—an oblique thrust at Palmer himself. But it was ridiculous of Linnell to think this, for although one cannot ignore Milton's beliefs, one is not called on to believe them oneself. T. S. Eliot says this when referring to Dante, and indeed it equally applies to Chaucer or Aeschylus. Admittedly, Milton's hatred of monarchs and priests coincided with Linnell's views, so he disliked all Johnsonian criticism of both Milton's life and his poetry. Nor would Palmer have liked Johnson's judgement on the harsh diction, uncertain rhymes and unpleasing numbers of 'Lycidas', the 'deficient drama' of *Comus*, and the reader doing no more than admiring 'Paradise Lost', then putting it down for ever.

Palmer's love of music was lifelong, and although early in life he had deliberately given up practising the violin in order that he might paint, he acquired much knowledge of music through listening. Such settings of Milton, now rarely heard, as Henry Lawes's of *Comus* and Handel's of 'Il Penseroso', delighted him. On one occasion he remarked on the magic touch of Handel's descending semitone for the 'Shadows brown that *Sylvan* loves Of Pine, or monumental Oake'.

During January, while waiting to enter the Vatican, Hannah obtained a limited permit to copy Titian's 'Sacred and Profane Love' in the Borghese Gallery. She worked in water-colour for six days only from 9 a.m. to 3 p.m., and she thought it her best work.

Not surprisingly, the 'Sacred and Profane Love' was the finest Titian she had ever seen for beautifully related figures and perfect spacing—and Palmer agreed. Again it was the lyrical Giorgionesque idyll, the enigmatic *poesia* which appealed to him. Again it was the ideal and satisfying landscape in the evening light at the back of the two figures, and the castle-cum-farm on the left, so similar to Giorgione's Dresden 'Venus', on which they comment. The picture on its thinly primed canvas was then in need of cleaning, the purple hellebores in the foreground being indistinct, as was the edge of the red garment under the silver gown of the left-hand figure. Yet the broad full light on the figures admirably contrasted with the 'great plates' of dark, rich, local colour on the trees behind them. The sun was bright for Hannah, and as in all Roman palaces there was reflected light from the floor, which helped her to copy the details.

In the middle of February permission to draw in the Vatican was at last granted by the authorities. So with an 'opera glass' which she had bought Hannah was able to see clearly the most minute work in the huge curved ceiling of the Sistine Chapel, especially as it had been cleaned with bread since her previous visit. After three weeks all the prints had been coloured, by either Hannah or Samuel, who had worked continuously. He was not satisfied with them, as the prints were not like the originals in many essential features. The angles of heads, knees, and elbows, so striking in the originals, were tamely drawn, lacking all pungency and spirit. Although he admitted that Linnell's engravings, which were the best he had ever seen, were enriched by being washed with the appropriate colours, Palmer worked on them himself, altering the chiaroscuro of the prints, where necessary putting emphatic lights at one or two points. However, there were linear inaccuracies. So he redrew many of them, and was pleased with the result, which recovered some of the effects of the frescoes. He continued to redraw many of the others, as he thought it was better to have them done properly.

One such example of bad drawing in the print was the David and Goliath, on the left, in the triangular ressault at the end of the Chapel opposite the Last Judgement. The knee of the giant in the original is below his right elbow, his head is as high as his back, and there is a 'deathly shrug' which was entirely lost in the print. But

Palmer had doubts about finishing the Loggia before the hot weather if many of the Michelangelos were redrawn. He told Linnell he knew no German artists whom Linnell suggested for copyists, nor had he any connections with any. Most of them being 'grand bewhiskered geniuses' whom he had seen about, he would be afraid to ask them to finish copying work which he had already started. By the end of April he had revised nearly all of the prints, being much pleased with the result, which he thought justified his action. The Prophets and Sibyls were especially successful after alteration and when held up against the originals seemed to have the same breadth and grandeur in the general proportions of form, colour, and effect 'of Michelangelo's peculiar light and shade, developing forms of antique breadth with the vigour of Rembrandt, the bloomy gradations of Correggio and the twilight of Da Vinci'.

At this time George Richmond was doing well in Rome, meeting Gladstone and Dr. Manning,[1] and mixing in Vatican circles which included Cardinal Mezzofanti. He asked Palmer to tell Linnell he had bought for twelve shillings a set of engravings of the Raphael ceiling in the Chigi chapel in S. Maria del Popolo. These dome mosaics, executed from Raphael's cartoons, with their glorious blue and gold tonalities, are strongly neo-platonist in feeling, so appealing to Palmer. God the Father, in the crown of the dome, from the blue air guides the planets and stars below him. This was an astrologic domination from Dante known to the humanist Agostino Chigi, whose sepulchral chapel it is: the imagery, outwardly Hebraic or Christian, is equally Hellenic or Virgilian. In the hall of his Farnesina Palace the setting is entirely pagan, the two central scenes being a reconstruction of Agostino Chigi's horoscope for the day of his birth. Palmer saw these and admired them; but of all Raphael's work he thought the Foligno Madonna 'the finest easel picture in the world'.[2] Actually he was mistaken about its being originally an easel painting, for it had only recently been put on to canvas after damage when it had been removed by the French in

[1] Some years later Dr. Manning baptized John Giles, Palmer's cousin and a strict Nonconformist, into the Church of England.

[2] The Foligno Madonna, canvas, 320 inches by 194 inches, Rome, Pinacoteca Vaticana.

1797. It had been commissioned for S. Maria d'Aracoeli and appropriately the Madonna and Child are on the Altar of Heaven, enclosed in an airy circle. Below her on the ground are an ecstatic St. Francis and St. John Baptist on one side, and the donor and a bowed St. Jerome on the other, separated by a *putto* gazing upward and holding a tablet which must have borne an appropriate inscription. But it is the colouring of the landscape behind the *putto* which especially appealed to Palmer, even though his eye was 'full of the wonderful Titian' ('The Feast of the Gods'), which he had been lately studying. The little city in the landscape of the Foligno Madonna had all the 'finest qualities of Turner' and a 'bloom so exquisite' that he thought it must have been 'assisted by the chilling or drying of the varnish', yet when he looked closely he found it had been 'all fairly painted'. This landscape has indeed magical highlights of silver-grey over warmer tones, but it is now generally thought to be the work of one of the Dossi brothers, the last of the Ferrarese painters. Dosso was placed by Ariosto, in his *Orlando Furioso*, as an equal to Michelangelo and Raphael. Whoever painted it, there is no doubt of its similarity to other *cinquecento* painting, and Palmer, who thought it was Raphael's work, is consistent in his admiration for landscape painting of this type and quality.

What had given Palmer most joy was permission for Hannah to copy the Titian-Bellini 'Feast of the Gods', then in the possession of Baron Camuccini. As Joseph Severn knew Camuccini, he had managed to obtain his permission for Hannah; although Camuccini had denied other artists, including the head of the French Academy at Rome, he could not 'refuse an English lady'. Palmer was delighted, as from his first sight of the picture he had never ceased to long for a copy.[1] Bellini's figures, he thought, were the most glorious combination of colour and sunshine, and Titian's landscape a 'pinnacle of triumphant execution'. So he wrote to the Linnells with what A. H. Palmer would have called a 'lack of masculine reticence' which must have appalled that serious family. 'When Mrs. Richmond suddenly told the news it had such an effect upon me that I

[1] As did Poussin, who made the famous full-size copy now in the National Gallery of Scotland.

screamed, fell flat upon the floor and kicked like a lady in hysterics
—then seizing a tambourine I performed a Bacchic dance with
agility which would have astonished you!'

'The Feast of the Gods', now in the National Gallery of Art,
Washington, D.C., is unique in that the figures are Giovanni
Bellini's and the landscape Titian's work—a perfect and rare
combination of *quattrocento* and *cinquecento* painting. Bellini did not
finish the picture, because, as Vasari says, he was old, although he
had signed it; then the Duke of Ferrara commissioned the young
Titian to do so. Two years later Bellini died. Recent X-ray studies
have revealed the extent of Titian's work—certain alteration of the
figures' poses and a complete overpainting of the background,
converting Bellini's continuous band of trees into a majestic tree-
clad, rocky hill.[1] The scene is a Bacchanale illustrating Ovid's
Fasti, book I, lines 391–440:

Naiads were there, some with flowing locks uncombed, others
with tresses neatly bound. One waits upon the revellers with tunic
tucked above her knees; another through her ripped robe reveals her
breast; another bares her shoulder, one trails her skirt along the
grass; no shoes cumber their dainty feet. So some in Satyrs kindle
amorous fires, and some in thee whose brows are wreathed in pine.
Thou too Silenus, burnest for the nymphs, insatiate lecher! 'Tis
wantonness alone forbids thee to grow old. But crimson Priapus,
glory and guard of gardens, lost his heart to Lotis . . .[2]

This is the moment in the picture, when Priapus, drawing aside
the quilt around Lotis's feet was about to embrace her. Then
Silenus's ass suddenly brayed and the gods awoke. A triumph of
chastity, but the gods—who are portrayed for the first time as
recognizable rather than idealized human beings—are not asleep
in the picture, but feasting. It is difficult to believe Hannah would
have made a copy of this scene if she had been the puritan she has
been termed; and this small copy, despite many offers to buy it,
remained hanging in their house for the rest of her life. Linnell had

[1] See Edgar Wind's authoritative work on this, *Bellini's Feast of the Gods. A Study in
Venetian Humanism*, Cambridge (Mass.), 1948.
[2] Ovid, *Fasti*, I, 11.391–440, translated by Sir J. G. Frazer, London, 1931.

seen Benjamin West's copy of 'The Feast of the Gods', and knew the figures were by Bellini and the landscape by Titian. But, marvellous though it was, he said he did not rate the painting as highly as the 'Sacred and Profane Love', though he must have made this judgement without seeing the original of either picture. Vincenzo Camuccini was known to John Linnell as the leader of the Italian historical painters of the time; much of his work was restoration: frescoes by Domenichino in Grotto Ferrata, and Pinturicchio in S. Maria del Popolo. He was not a very distinguished painter, but evidently a kind host. Copying the 'Feast of the Gods' was a welcome break for Hannah from the cold of the Sistine Chapel. She was in a warm and comfortable *palazzo* and obviously enjoyed it, even to making a lightning sketch of the baroness's King Charles spaniel. No doubt the Palmers also saw other pictures of Camuccini's: a Guido Reni Madonna; a sepia sketch by Raphael for the 'Deposition of Christ'; a Claude sea-port, a duplicate of the one in the Louvre; and, perhaps, some Domenichino frescoes, which, for want of room, he kept in a coach-house.

When Linnell received Palmer's letter about his wish to alter the Sistine Chapel engravings in some cases, he replied wisely that there might be and often were differences between the drawings and the final frescoes; but that Palmer should not bother about them too much, unless he thought the whole feeling of the fresco had been lost. Linnell considered his drawings, from which he had made the plates, to be the work of Michelangelo himself. Therefore on no account, he wrote, should lines be inserted which were not visible in the frescoes if viewed from a distance: for example, when a face was 'understood', as in his sketch (Plate 4*b*), where the lines to complete the form are missing and are replaced by touches of shadow, the gradations of which express more than lines can. He thought the greatest fault, after poor drawing, in all prints of the Sistine Chapel and Loggia, was an entire lack of proportion of emphasis, and the true expression of the countenances. Everything was vulgarized, as the character of the form was lost in the small scale of the print, except in those sets of engravings by Bonasone, Michelangelo's contemporary, whose work both he and Palmer had always admired.

Linnell wrote that he envied George Richmond his present opportunities to study and copy the Old Masters in Rome;[1] and he regretted that with responsibilities to his family he himself would not be able to do this. His main purpose in future would be to help others, and he encouraged Samuel with the thought that he was 'on the right road to distinction and need not care about present and immediate returns so much, for though in this age more perfection is required to obtain notice', yet Palmer had already mastered much. But this must have been cold comfort to Palmer, with no pictures sold in the Rome exhibition, no rents from his Grove Street house, and spending capital. Compared with Linnell, then aged forty-seven, his position was parlous. Linnell related he had just sold his 'St. John preaching' to Sir Thomas Baring for 150 guineas, and was embarking on engraving a Titian landscape in the Royal Gallery. This was the 'Landscape with Herdsmen' (1840), in a collection of prints entitled *The Royal Gallery of Pictures, being a Selection of the Cabinet Paintings in their Majesty's Private Collection at Buckingham Palace. Published under the Superintendence of John Linnell, Esq.* There are thirty-two engravings in this volume, Linnell's of the Titian being one of the finest, portraying the sky with the approaching storm most skilfully. The remainder, except for four of Reynolds's paintings, are all of the Dutch school. As well as undertaking this work, Linnell had just completed a portrait of Dr. William Crotch, the musician, which hung in the Royal Academy exhibition of that year.

Linnell promised Hannah and Samuel that on their return he would take them to one of Dr. Crotch's weekly musical parties at his house at near-by Kensington Gravel Pits. This, he admitted, was 'to atone for the animadversions' of his previous long letter, which evidently troubled his conscience.

Henceforward, for a few months, the tone of Linnell's letters softens, because they may be read by a certain Albin Martin, a pupil of his and friend of the family who had just arrived in Rome. Martin, having forgotten the Palmer's address, had found them by chance near their house, in Piazza di Spagna as he was walking

[1] Richmond was a hard worker, averaging eight hours' painting and drawing a day, as well as attending a life class for three months.

through with Edward Lear. He was a rich, handsome young man who, apart from bringing them cakes of pink madder, and taking them to the opera, sent back cheerful letters to the Linnells, which described the Palmers in glowing terms—'the happiest couple he had ever met'.

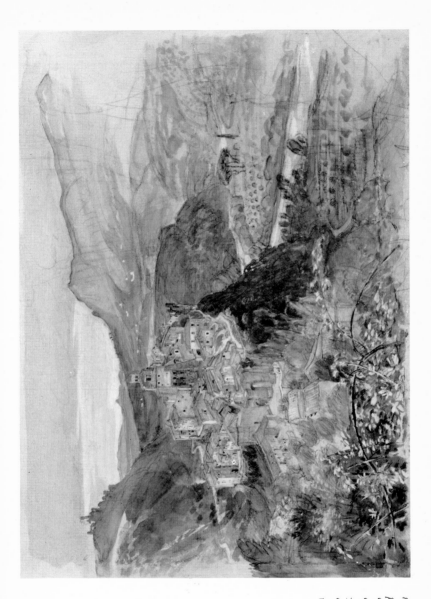

17. 'Papigno between
Terni and the Falls',
water-colour, black
chalk and body-colour,
by Samuel Palmer,
1839. *Victoria and
Albert Museum, London*

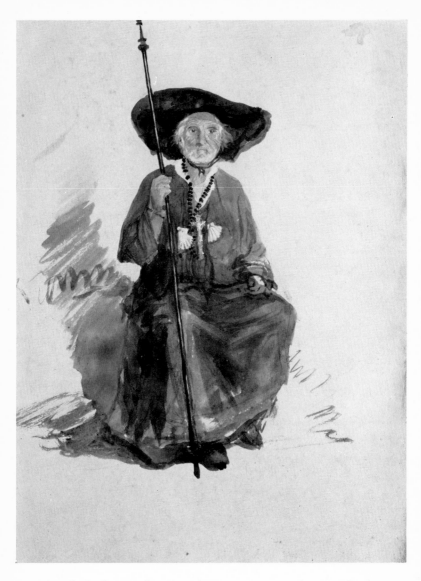

18. 'A Pilgrim in Rome', water-colour on grey paper, by Samuel Palmer.
Paul Mellon Collection

Umbria, Florence, and Home

With him [Palmer] there ended that beautiful
episode in European art which from Giorgione's
day till the nineteenth century had been a source of
enchantment and consolation.

SIR KENNETH CLARK, *Landscape into Art*

O N 24 March a welcome commission arrived with John
Linnell's letter. For some years Linnell had been friendly
with a certain Edward Daniell, a young man who came
from a rich Norfolk family and who painted in water-colours. During
this time Linnell had given him lessons, had completed a portrait of
his mother in oils, as well as miniature and full-size portraits of
Daniell himself.[1] After coming down from Oxford, Daniell was
ordained, and in 1838 was curate at St. Mark's, North Audley
Street, where his hospitality to artists and his paintings at the R.A.
may have been better known than his pastoral parish work. He also
knew Palmer and admired his work, having helped him to find a
patron on more than one occasion. In July 1838, he had offered
Linnell fifty guineas for his 'St. John preaching' provided it was sent
to the British Gallery and was not sold there. However, as we have
seen, Sir Thomas Baring bought it for three times that amount. In
the same month Daniell negotiated with the Art Union Society, of
which he was on the committee, and bought Linnell's 'Journey to
Emmaus' for sixty guineas, having it engraved later. Linnell visited

[1] The latter was in the Royal Academy in 1836.

his house frequently, and a scheme was concocted whereby he should paint a portrait of Turner, who also often accepted Daniell's hospitality. Unfortunately, Turner was opposed to having his portrait painted by anyone, so Linnell was placed opposite him at a series of dinner parties in the hope he would be able to make a sketch from memory. However, the result, smaller than life, was said to be not a very accurate likeness. Daniell had been to Rome in 1830 and had formed opinions of the chief Raphael frescoes of the Vatican; the 'finest piece of colour' according to him being 'The Disputà', on the opposite wall to 'The School of Athens' in the *Stanza della Segnatura*. So Daniell, doubtless at the instigation of Linnell, commissioned Hannah to make a water-colour copy for which he would give her £25.

In his letter Linnell gave advice on the quickest method of achieving this, which he considered a week's work: by tracing the outlines of one of Giovanni Volpato's prints on strong but not too smooth paper. Then, as Daniell was interested chiefly in the colours, to give a general effect rather than an accurate drawing, by making a vigorous marking of all the light, leaving the shadows white until 'every requisite form was safe and strong enough to bear the tones to be washed in full as nearly at once as possible without obliterating the forms'. To the Palmers, the thought of £25 must have been welcome, though the difficulty in completing all the work in the time was daunting. Fortunately, Samuel managed to find an Italian artist, recommended by a friend of Sir Augustus Callcott, who would copy the remaining thirty-two Loggia pictures for four scudi each (about seventeen shillings), which Palmer thought was reasonable, as they would take him at least a day each. So if Linnell could be persuaded to accept that price all would be well. 'The Disputation of the Sacrament' in the vast lunette, with its radiance of other-wordly light interested Palmer for its contrast with the grave, grey tones of 'The School of Athens'. The Dantesque theme is the unity of Faith and Truth in Heaven and Earth, 'The Disputation of the Sacrament' being a misnomer based on a wrong interpretation of long standing. Above all sits God the Father surrounded by angels, below him Christ enthroned and flanked by the Virgin and St. John Baptist. Around this central group are figures

of the Saints from the Old and New Testaments, all of whom are placed on a wreathed and cloudy division. Linking the upper and lower halves of the fresco are the Dove, and cherubs holding the Gospels from which golden rays descend to the Holy Sacrament in a monstrance—the magnet to which all lines point. It is very typical of neo-platonist thought that these two frescoes should be opposite one another: personifying the religious and the philosophical learning which combined in Renaissance culture.

Albin Martin also gave Palmer £5 for a little sketch (5 inches by 7 inches) which he had done from the bedroom window at Cava at two o'clock in the morning. As they now had only £20 left, this helped their finances and as they were working hard on Linnell's commissions, they had the prospect of receiving some money on their return to England. But gradually the work began to tell on Anny, as it had the previous year; and Samuel realized he would have to work on Daniell's commission while she completed the Loggia. She wrote pathetically that she had read no books, as she was so tired in the evenings she felt fit for nothing but knitting. They were both dispirited to think how much was expected of them; it was so easy at a distance to fancy cartoons, studies, recollections, etc., of the Sistine Chapel, but how difficult to complete them. And it was an unfortunate time for Palmer to have to be bothering about this work, as the weather was becoming warm and ideal for outside studies. As Anny worried unduly she started to have nightmares about her work: one that a new principle of drawing had been started by which eyes, nose, and mouth had to be introduced into every object she drew; another that a friend had sponged out all the trees in her copy of 'The Feast of the Gods'. Palmer was rightly anxious.

Linnell's next letter, before he realized how the work was becoming too much for Hannah, cannot have encouraged them. He says he could not afford to give a stranger nearly £30 to complete the thirty-two remaining Loggia drawings, as he has little faith in modern German or Italian artists; but he was prepared to offer one £15, if Palmer would supervise what he did. Then, contradicting all he had previously advised, he recommended they did not quit Rome so soon, unless it was necessary for their health, obviously hoping they would stay on to complete his commissions. Lady

Callcott had apparently told him one could stay in Rome all summer provided one did not go out before sunrise or after sunset.[1] And Linnell hinted it was Hannah's work on the 'Camuccini Titian' rather than the air of Rome which had spoilt her health.

As a postscript to the letter, Linnell remarked on seeing Mr. and Mrs. Edward Calvert many times of late, and that Calvert said he intended to write to Palmer, but had not got around to it. As we have seen, Calvert never did bother to send them a letter, despite Palmer having written over 2,500 words to him from Naples, as well as a note from Rome in the hope of persuading him to send news. A. H. Palmer in one of his acid comments thought Calvert cared as little for what his fellow 'Ancients' were doing as he did for his 'long-suffering wife in a dingy house in Paddington'. But it seems unlikely his house in Park Street, Paddington Green, was 'dingy'—certainly there were open fields and woods near for his children to play in—and about this time he had built a studio, with inner sanctum, sufficiently large for Landseer to get a horse in as a model.

On receipt of Linnell's letter the Palmers were placed in a difficult situation, which conveniently provides a combustible fuel for another of A. H. Palmer's fiery diatribes against Linnell, whom he describes as

full of suspicion and fear of being cheated, and anxiety to strike bargains. Fresh burdens are relentlessly piled on Palmer's back, and fresh responsibilities on his wife, connected with the commission to her 'in lieu of a dowry'. . . . All were to remain at Rome hard at work in the Sistine Chapel and the Loggia through the best of the spring weather if it were needful . . . Hannah was again to run those risks of illness. He says that he will provide the money for this and that luxury, but never did so.[2]

Palmer replied that even if he worked with the Italian artist all day in the Vatican they could not get the Loggia finished in a week. So he suggested that colouring sets of prints might have to be a substitute for the drawings. Then he said with more force that

[1] She was hardly the one to advise, as she was an invalid, perhaps because of her over-exertions in Italy.
[2] Ivimy MSS.

Hannah had been affected by the air of Rome as it became warmer, so they should leave shortly. It appears she was nervously strung up through overwork in the heat, and was not having a sufficient diet, despite the addition of port wine at lunch-time. April and May are usually considered pleasant months in Rome, though the heat can be enervating. In Hannah's case the long hours of sedentary work in the Vatican took away both her appetite and her energy.

Albin Martin, though not feeling well himself, splendidly came to the rescue by agreeing to colour prints of the Loggia for a week. In addition, he took the Palmers to the opera—a welcome relaxation. More important, he wrote himself to Linnell telling him it was utterly impossible, and indeed, imprudent, to make coloured drawings of the Loggia with the hot weather coming on. He stressed the point by commenting on Hannah's health, which had been excellent when he arrived, but had deteriorated since the advent of warmer weather. Both he and Palmer thought contemporary Italian painting was inferior to English, thereby agreeing with Linnell, who did not think an Italian was capable of copying the Loggia satisfactorily. Palmer thought the work of most foreign students in copying was weak, despite all their academic drilling. He had seen copies in the Stanze which were the size of the originals, appearing at a distance very like the Raphael drawings, but on close inspection he found 'the breadths cut up, emphases omitted, and high lights extinguished'. Albin Martin also thought the figure drawing of the original frescoes by pupils of Raphael was inferior work, as well as the colour in many being much faded. George Richmond believed Raphael never designed the colour. In any case, today, it is the *grotteschi* which are of most interest in the Loggia, but none of them mention these. In comparison, they thought even the bad light, dirt and discoloration by incense in the Sistine Chapel could not detract from the figures of Michelangelo, although the 'Last Judgement' seems to have been in a bad state, having been badly cleaned, so that the blue in the background had been scraped down to the white ground; besides all this, the large, lightly coloured velvet canopy for the Pope had been fixed with four iron bars to the fresco itself.[1]

[1] 'Universally the most damaged of all works—but even in this mutilation they are surprisingly grand.' George Richmond's *Diary*. Richmond MSS.

Martin also agreed with Linnell in his estimate of contemporary Italian art—'third-rate performances after the manner of Stanfield and Harding'. This implies the accurate, conscientious work, much admired at the time, 'The local colour of Stanfield's seas', according to Ruskin, was 'singularly true & powerful & entirely independent of any trick of chiaroscuro'.[1]

Fortunately, Palmer had time to do some work of his own, especially practice in drawing foregrounds from nature, which were broad and simple, leading the eye away from the centre of the picture, as in Gaspar Poussin's roads with large rocks or sandbanks, and he convinced himself he was making steady progress. He also expressed a wish to start painting quick sketches in oils—a wish not fulfilled in Italy, and commented on later by Linnell.

When the letter about Hannah's ill health was received in Bayswater, Linnell was filled with remorse that he might in any way have been the cause of their staying in Rome longer than they ought, and he suggested they leave *immediately*. He could not refrain from hinting once again that copying 'The Feast of the Gods' might have added to her burden, and that the Loggias should have been completed before they left for Naples; though, as we have seen, the former was as untrue as the latter was impossible. Yet Linnell made it quite clear that the whole Vatican copied would be no compensation for Hannah's ill health. With his customary tactlessness he says he wished for the 'pen of a ready writer' to influence Palmer to take more care of 'our dear Anny's' health, which should not be 'indulged' by Palmer, 'though ever so advantageous'. Having got them into a situation in which his daughter's health had indeed been jeopardized, Linnell now endeavoured to shift the blame upon Palmer for accepting the commission. It was palpable self-deception. Yet this was not the limit of his attack, for he stated clearly that Palmer's religious persuasions limited his daughter's love for her father. He writes to her: 'I have the most perfect confidence in your filial affection, indeed I believe there is only one thing which can ever prevent your pure feeling in this respect—I mean a mistaken sense of religious duty through a greater regard to the traditions of Man than the pure word of God.' Then he added

a final suggestion that on their return from Italy Hannah 'must be ours' for a brief period.

In a letter to Albin Martin, Linnell says the R.A. exhibition pleased him, especially a 'capital picture by a Mr. Redgrave of the daughter of the Vicar of Wakefield returning to her home when she is met at the door by her sister', and he comments on the affectionate love of the sister 'shown so pathetically in her face' that it 'excited the feelings as much as a very touching piece of acting'.[1] Here, at its worst, is the Victorian attitude to genre painting with a moral attached. Even from a painter to a fellow painter, there is no comment on Richard Redgrave's ability, only a sentimental note on the subject-matter. No wonder the sale-rooms of the 1860s were filled with such works, and no wonder Palmer never became such a painter. Another contemporary whose pictures of animals reek of sentiment—so different from his sensitive early landscapes—was Landseer, to whom Linnell also at that time lent his studio for him to finish his large portrait of the Queen.

In Rome, the Palmers abandoned the idea of employing an Italian artist for copies in the Loggia, Martin coming to the rescue by colouring prints. In the meantime Samuel himself finished the Daniell commission for the 'Disputà', as well as the Sistine Chapel drawings, which took longer than he anticipated. For example, the Prophet Jeremiah, that sorrowful and pensive figure, one of the twelve prophets and sibyls, alone took him several days. With astonishing courage, considering she was not feeling fit, Hannah wrote of her enjoyment of Italy, its delightful language and the climate outside Rome. Her language teacher had taken them to his box at the opera, which Hannah says was 'a new performance and the first time . . . it was an opera of the story of Queen Elizabeth, the Countess of Essex and the ring'.

After all three of them had worked daily, the Loggia pictures were finished by 23 May. They seriously had considered leaving Rome before the beginning of May. However, by a stroke of luck, the *sirocco* changed to the *tramontana*, and with it the air became

[1] Olivia's return to her parents. 'Being unable to go for my poor child myself, as my arm grew very painful, I sent my son and daughter, who soon returned, supporting the wretched delinquent, who had not the courage to look up at her mother', Oliver Goldsmith, *Vicar of Wakefield*, Chapter XXII.

cooler and fresher, amending Hannah's lethargy and ill health. This startling change in the climate of Rome with this change of wind can indeed alter the health of those who are not accustomed to it. So Hannah struggled on with colouring the prints without hurrying, and Samuel retouched the final work, which they thought had come out better than in the drawings done the previous year. Their understandable relief at achieving this before they left is very evident.

After a few days more at Tivoli, where they said good-bye to the Richmonds, who were returning to England on 17 June, they made a twenty-seven-mile journey on donkeys, with a horse-drawn cart containing their baggage in the rear, to Subiaco, in the mountains. A coach would have been more comfortable and safer, but also more expensive. Palmer's donkey became dangerously entangled with the wheels of another cart, and Hannah was thrown from her donkey, but they arrived unscathed after being benighted in the mountains near Subiaco. This medieval town, at the head of the Aniene valley on the western slopes of cultivated hills, provided many subjects for sketches, of which he made memos in his book, afterwards to be destroyed with others by his son.

Having got rid of the strains of copying in Rome, he was now free to paint with a constant reference to nature ideally studied. At this time he stated what he hoped to achieve in the future, expressing a dread of his return to London, where he would be in competition with 'popular art'. Evidently he sensed the direction which popular taste would go, led by the Queen, who thought Hayter's work was superior to Lawrence's 'daubs'. Nor could Palmer feel happy in a Biblical, historical genre like Wilkie's, nor in portraiture such as Linnell's, nor was he the sound, academic draughtsman like Mulready. These styles he knew he could never achieve. Throughout Italy he was absorbed by the 'deep-toned and remote grandeur of Titian and the finest efforts of Nich. Poussin'; in fact, in the ideal landscape genre. With reference to his hopes he writes that

foreground and landscape figures are at present my object—with a watchfulness after phenomena of skies and effects dependent on them by which I have profited of late. As trees are a part of foregrounds I am anxious by degrees to master each class, and by a very abridged

process have learned the general characteristics of the cypresses from those in the Villa D'Este which are reckoned the finest in existence. . . . It is the fashion of English landscape painters and amateurs to say that fine subjects may be met with everywhere. I think them extremely rare, having never for instance seen the wild winding, romantic lane in any degree of perfection till I found it here. I have great hope from massed and classified study, and as I am willing to indulge any degree of labour, study and application, hope soon to reap a reward. . . . I feel nature to be no longer a disorderly heap of beautiful matter perplexing from its intricacy and profusion, but a treasury able to supply every want of which the student is distinctly conscious.

He also hoped to have amassed a stock of the choicest wild fore-grounds capable of framing and sustaining the grandest distances.

When they received John Linnell's letter in which he blamed Samuel for not taking care of Hannah, they both replied in more outspoken terms than they had used previously. Hannah, having declared she was perfectly well again now she was in the country, said 'Mr. Palmer feels a good deal hurt with your letter. I must say I do not think he deserves it as he has taken the greatest care of me, indeed, dear Papa, the most affectionate and solicitous care'. Palmer said it was ridiculous to comment on Linnell's supposition that he never really wished to complete the Loggia drawings; but he could not let pass Linnell's remark, 'Anny must be *ours* again for a time on your return'. He disliked the word 'must', and made it quite clear that parental control of this sort was out of the question. On his return he hoped to place her in a comfortable, though humble position in Grove Street. To Mrs. Linnell he wrote equally firmly:

Let me conjure you to correct that unjustifiable and distrustful anxiety which at once embitters and falsifies your views of the future. *You* write calmly, Mr. Linnell excitedly; but I know very well that Mr. Linnell's distress half arises from daily witnessing *your* unhappiness. Why should you be unhappy? Your daughter is well and unhurt, and has spent nearly two years in acquiring intellectual and moral power, and experience which with the blessing of Divine Providence, will lead her safely through the mazes of life. If you could

have the advantage of a few such months of travel and adventure you would see the unreasonableness of all such hideous surmisings. Anny never thinks of the morrow, but endeavours to provide for it by doing the duties today. How odd it is that her cheerfulness has supported and cheered *me* in all times of depression, and yet that this happy being has been unconsciously the cause of such hideous apprehensions. I hope you do not directly or indirectly attack Mr. Linnell for letting her go, for all your unfavourable prophesyings have been falsified, and Mr. Linnell has so many things to irritate and exhaust him that a continual annoyance at home will embitter if not shorten his life.

The Linnells deserved all of this, which Palmer must have found difficult to write, as he was not easily incensed. However, his estimate of the extent to which Linnell might be exhausted by worry was faulty. All his life, working incessantly, Linnell seemed to thrive on problems of this sort and he outlived Palmer.

Typical of Linnell's attitude is his next letter in which he seems quickly to have forgotten all about the difficulties of making copies in hot climates in a limited time; so he suggested they make a coloured copy for him of Michelangelo's 'Circular Holy Family' in Florence. By this he meant the 'Doni Madonna', Michelangelo's only easel painting. It was strange he should wish for a copy of this, as on the whole in the nineteenth century it was considered an unsuccessful and unsuitable treatment of the subject. The miracle of composition and draughtsmanship with the cool, clear colours was appreciated, but the muscular, unveiled Madonna, so like the Delphic sibyl in the Sistine Chapel, the Joseph with a head like an antique portrait, and the classically wreathed Child on the Virgin's shoulder, were all pagan in feeling; as indeed also is the bevy of Greek athletes who lounge in the background, though they are separated by a wall from the Holy Family: all wonderfully painted —'broad, soft luminous', according to Palmer. This precursor of much of the figure drawing of the Sistine Chapel ceiling was again a mixture of Christian and pagan successfully synthesized.[1] Linnell's advice in answer to Samuel's queries on art matters was

[1] See Charles de Tolnay, *The Youth of Michelangelo*, Princeton, 1947, p. 165, for a full discussion.

fully and carefully given, and was both encouraging and wise. He did not like the idea of Samuel doing 'little oil pictures and drawings painted in a day at once from Nature'. It savoured too much of the cheap pot-boiling stuff which already flooded the art market. It would be better in the future to teach, leaving time to take pains with work for exhibition. He thought Samuel was in a strong position, and urged him to take care of all he had done, not under-valuing it just because people had not as yet appreciated it. In practical matters, with regard to the redecorating of the interior of Grove Street after the lodgers had left, or of methods of getting more letters of credit to Italy, or of collecting the half-yearly rent from Shoreham, Linnell was both helpful and discerning.

Hannah's young brothers, John, James, and William, did not inherit their father's ability to write, though they showed a certain literary knowledge. They appended a brief, colloquial note to the end of their parents' letter as follows:

Balcony Room, 38, Porchester Terrace.

1st Boy: To all you chaps in Italy, we chaps at home indite; but first we'd have you understand how hard it is to write.

2nd Boy: When shall we three and you three meet again?

3rd Boy: Wishing you every happiness and everlasting joys we sign ourselves yours truly most unruly Boys. JL TJL WL

Towards the end of June the heat became exceptionally oppressive in Subiaco. So the Palmers moved nine miles up to Civitella, a village within walking distance of Olèvano. Perched on the summit of a high single rock it can be seen from far away, as in Palmer's water-colour.[1] The reason for the unfinished state of the foreground in this drawing may have been because Samuel was not well. He certainly remarked on having no appetite for a week, and on feeling depressed about his progress. Martin also was ill, being in bed for some days with a stomach complaint which caused vomiting. But after these attacks had passed they lived comfortably in a *pensione* with about a dozen artists of many nationalities, including Edward Lear, whose flute playing was beautiful, but whose drawing was not

[1] 'Civitella near Subiaco', water-colour with gouache and black chalk on buff paper, $11\frac{1}{2}$ inches by $16\frac{3}{4}$ inches. Whitworth Art Gallery, University of Manchester.

commented upon by the Palmers. His wash-and-ink drawings, subsequently lithographed as his *Views of Rome and its Environs* (1841), have many common subjects with the Palmers: Cervara, Tivoli, Civitella, and Subiaco, as well as some in Rome. His treatment of foregrounds, often with boldly drawn foliage of semitropical plants and olives, is more successful than Palmer's, and his interest in the flora and fauna of the country is incomparably stronger. For this volume, Lear's list of aristocratic subscribers headed by the Queen, Prince Albert, and the Queen Dowager, is something Palmer must have envied. What Lear described as a 'totally unbroken application to poetical-topographical painting' being 'a universal panacea for the ills of life' was also a situation Palmer might have wished for, especially when he was forced to devote time to copying endless frescoes for Linnell. The view from Palmer's window at Civitella was outstandingly beautiful, across the *campagna*, to Rome, beyond which they could see the blue Mediterranean. In his diary he wrote: 'Suddenly at a turn in the mountain road, we looked for the first time on that Plain; the dispenser of law, the refuge of philosophy, the cradle of faith. Ground which Virgil trod and Claude invested with supernatural beauty, was sketched—but with a trembling pencil.' By living sensibly, rising before five o'clock in the cool of the morning, taking a prolonged siesta after lunch and eating trout and fowl, they were able to achieve much work, especially excellent foreground studies of rocks and woods.

Certain news from home was cheering: both the Shoreham and the Grove Street tenants had paid their rents. On the other hand, Linnell reacted badly to Palmer's outspoken reply to his criticism of not looking after Hannah, and of never wishing to complete the Loggia. Palmer's 'touchiness of disposition calculated to stop all free intercourse', etc. etc., wrote Linnell, who did not retract anything which he had written. It would be difficult to imagine him ever recanting, so determinedly uncompromising was he in his ideas. There was a tough streak in his character which not only stopped any displays of grief on bereavement, but drove him on to keep at work even when he was in poor health. Frequently in his dairy there is the entry, 'not well' or 'very ill', yet in the afternoon in question

he often completed a portrait commission. His love for Hannah seems to have been one of his strongest personal emotions, and it was lifelong. On his death-bed he asked only for her. But it cannot have made him an easy father-in-law. An insatiate desire to see her soon now dominates his letters to Italy. She must return quickly as 'Mamma is very poorly' . . . and if Hannah delays her return it might 'affect Mamma's health materially'. And he harbours suspicions like 'if I could feel certain that you were happy I should be content though I long to see you, but I have strange qualms sometimes'. Constant pressure of work, as if he was in a treadmill, seemingly obliged to go faster than he wished, cannot have been conducive to calm thought or considered opinions in letters when in the evenings the wheel of daily work stopped.

After a month at Civitella the Palmers returned to Subiaco by moonlight on mules, preparatory to making their way to Terni. They left in a hurry because Hannah, on looking one night out of her window had seen two corpses being carried to be buried, 'the one yellow, the other green and spotted'. The 'putrid fever' (typhus) was raging at Gennazzano, in the valley below Civitella, nine miles away, and when it was rumoured it had arrived at Civitella they decided it was time to leave. Their tales must have alarmed the untravelled and over-anxious Linnells. Yet journeying at night was considered safe, and vipers, fleas, bugs, mosquitoes, and scorpions, which they also mention, were common hazards. They were safer in the mountains than in the *campagna*, where the 'bad air' (mal-aria) of the marshes was raging.

Wisely, they decided to spend the rest of the summer in Umbria and not to hurry on to Florence, which was stiflingly hot. So they moved north to Papigno, near Terni, a small mountain village about three miles from the Cascata delle Marmore, where the Velino plunges for about six hundred feet over a precipice into a dark and wild valley. In those days the river had not been diverted for industrial purposes, so the roar of the waters and the long sheet of foam from the headlong height were more picturesque and sublime than they are today. Writers and painters had often been drawn to the spot. Addison supposed it to have been the place mentioned in Virgil as the gulf into which Alecto, the fury, is received on her way

back to hell.[1] Byron thought the spot was worth all the cascades of Switzerland put together. Shelley, writing to Thomas Love Peacock, said his imagination was bewildered by it:

> Words, and far less could painting, will not express it. . . . You see the evermoving water stream down. It comes in thick and tawny folds flaking off like solid snow gliding down a mountain. . . . Your eye follows it and it is lost below, not in the black rocks which gird it around, but in its own foam & spray, in the cloud-like vapours boiling up from below. . . . It is as white as snow, but thick and impenetrable to the eye.[2]

But the Palmers thought it overrated, though fashionable, like Murillo's paintings. They had seen more picturesque falls in out-of-the-way places, and Martin agreed—'not equal to many falls in Wales'. However, the Palmers, like Turner, Lear, and 'Spanish' Lewis, made the falls a subject for water-colour drawing. At Papigno they lived in comparative comfort. A donkey with a servant carried Hannah, her easels and drawing materials every day. They lived in a pleasant house and the weather became cooler. Palmer's fine water-colour now in Bolton Art Gallery was started here.[3] He has been completely successful in dealing with the poetic foreground of rocks, the figures, especially the child with the classical raised arm he so much loved, and Papigno perched on its rocky eminence. Apparently he has worked with a lack of effort and quicker than usual, resulting in much freshness. The crescent moon rising in the sky lit by the sunset after-glow links the skies of the Shoreham period with the later etchings.

By the beginning of September, Palmer had finished all the drawings he wished to make at Papigno, so they decided to move on to Florence forthwith. Except during the very hot weather, the visit to Umbria had provided them with many subjects. Before they left he wrote asking Linnell for advice about the completion of their journey. Should they return immediately in order to prepare for the

[1] *Aeneid*, Book VII.

[2] To Thomas Love Peacock, Terni, 1818.

[3] 'Papigno below the Falls of Terni', water-colour on buff paper, with black chalk and body colour, 20¼ inches by 27¾ inches.

spring exhibitions at the R.A. and elsewhere, omitting Florence? Or, while they were in Italy with few hopes of returning soon, should they stay in Florence, seizing the chance to make select copies as well as water-colours in and around the city? This latter course would bring them to the end of November before leaving, which would not give them sufficient time to prepare for the spring exhibitions. Palmer was obviously genuine in his wish to know Linnell's opinion on the matter: 'I lay these two plans of proceeding before you—unswayed by any *secret* wishes and wanting your deliberate opinion—unbiassed if possible even by the strong desire which both you and Mrs. Linnell must feel of seeing Anny near you once more.' In order to be careful not to offend Linnell, Palmer made over a hundred corrections between the rough and the fair copy of this letter which he sent, knowing how easily his motives had been misinterpreted in the past. But they were fruitless corrections, as Linnell's reply subsequently shows.

The same problem that had occurred in Rome concerning the Linnell commissions now repeated itself with fiercer energy. Linnell was again torn between his desire for copies of the 'Doni Madonna' and the Titian landscape, and his wish to see Hannah again as soon as possible. The Palmers were split between their intention to see the best of Florence or to return in time for the spring exhibition at the Royal Academy. As it happened, they stayed in Florence only about six weeks, on account of bureaucratic delays in obtaining permission to paint in the galleries. So all the heat of Linnell's anger at the thought of their staying another winter in Italy could have been avoided.

Once again it is Titian and Giorgione which most interest Palmer. The landscapes in the two Giorgione panels, 'The Judgement of Solomon' and 'The Trial of Moses', absorb him. These are idyllic scenes, with distant water, mountains, towers, and groups of buildings, and, above all, the nearer trees with their exquisitely painted foliage, highly finished, but with only a few small pencil touches to complete the masses—all the breadths being done 'with large tools, most perfectly'. So much was he influenced by these poetic landscapes that he says he could never paint in his old style again, even though he might paint worse. But he is fully conscious

of the difference between admiring and imitating, so his work would not be mere Titianesque sketches. Nor would it be in the fashionable current 'Italian' style, as exemplified by Uwins—'all chrome and cobalt'—but of 'deep sentiment and deep tone'. With pathetic ingenuousness he told Linnell, possibly for the last time, that he looked forward to his instructions with regard to painting, which he had previously found beyond price. Although he now said he realized they had better stick to art matters, making it a rule not to talk on subjects on which they did not agree.

But by now the relationship had ceased to carry the mutual passage of ideas, so greatly had personal differences weighed it down. Linnell replied that he could not find any argument for their staying three months longer in Florence, which would not apply to their staying three years. But he thought Palmer's mind was set on staying, so there was no point in his saying more. Then follows a passage in which he once again tries to undermine Hannah's loyalty to Samuel:

I think, my dear child, that you are deluded if you believe that Mr. Palmer contemplates returning this year. He may not exactly be aware of it himself, he may fancy that he is debating the question when he is only hunting for some excuse to stay . . . how unreasonably suspicious he thought me when I said he was only breaking the ice for another season in Italy. So it appeared to me and so it appears to me now, for he mentions a season for returning which I cannot believe he can intend & which he knows will furnish abundance of too plausible reasons for stay, & even for going southward again. These are all the mean stale tricks which are so successfully practised chiefly by the despotic party & by all parties I am sorry to say when opportunity offers. Do not you, my dear girl, follow such counsels . . .'

After this, in a part of the letter addressed to Palmer himself, Linnell tells him he should keep his religious views for imposition upon children—evidently a sarcastic reference to Palmer taking Hannah and Lizzy to Church of England services—and upon 'silly women who are not aware of your tricks'. Then Linnell said he was too busy to attend to Grove Street affairs any more and that they had better return to handle them themselves. Finally, the maudlin sentiment repeated, that if they stayed another year in Italy no

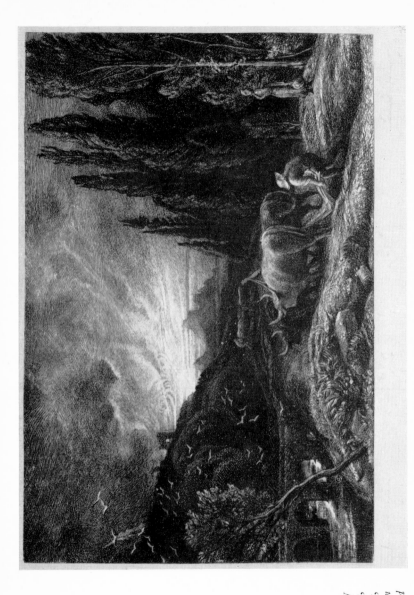

19. 'The Early
Ploughman', etching,
by Samuel Palmer,
1868. *The Ashmolean
Museum, Oxford*

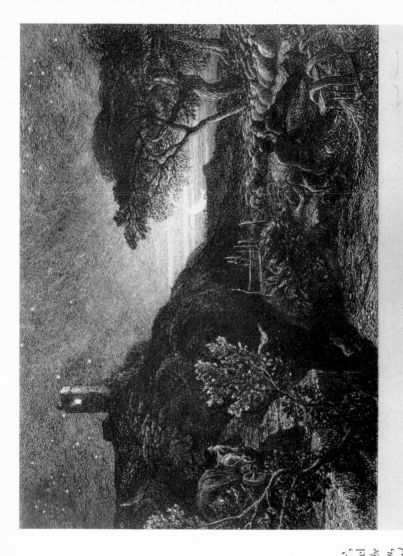

20. 'The Lonely Tower', etching, by Samuel Palmer, 1880. *The Ashmolean Museum, Oxford*

medicine could cure Mrs. Linnell's ill health through pining.[1] She was reading Xenophon's 'The Expedition of Cyrus' (in translation) at the time, and commenting on it intelligently, so presumably she was not prostrated.[2]

In a letter ten days later he still continued to try to divide them yet he longed to have a study of the Giorgione and Titian landscapes. 'Get what you can', he urged. This letter culminates in a final petty threat: as he would have a larger bill to pay for their letters (1*s*. 7*d*. each), he would not stick to his bargain to pay for them, but would make Palmer pay if they stayed any longer. Perhaps this was an attempt at grim humour, as, in fact, Linnell was very generous in secretly helping to maintain many poor relations of Mrs. Linnell's and his own family. Then in the last paragraph which he wrote to them before they left Italy he declared he was willing to discuss the making of poetic landscape with Palmer, who must devote his whole mind and time to it if he wished to succeed. Linnell thought he had failed himself, being too old to rally sufficiently to improve (he was only forty-seven).

Palmer, in a reply to a letter of George Richmond's from his home in Marylebone, summed up the Italian trip:

my knowledge of composition & of the phenomena of nature have materially increased—but if on my return I should find myself able tolerably to realize my present *idea* of landscape I am far from flattering myself that it would ensure popularity—the modern English art is all bustle—surprise—excitement—or else a plausible imitation of the texture and surfaces of things—neither of which seem to me the legitimate aim of our profession—so that I propose honestly to get my bread by other means such as teaching &c.—& to paint for love.[3]

In that he foresaw the life which he was to lead, and fulfilled it according to his wishes, never being content with the 'texture and surfaces of things', it is difficult to understand A. H. Palmer's view that his father had failed.

The Florentine visit must have been most worth while. Hannah

[1] She survived until the age of seventy. 'The personification of gentleness and piety; her patience had no end'. A. Story, *Life of John Linnell*, 1894, Vol. 2, p. 262.

[2] *The Anabasis*, including the Exhibition of Cyrus, London, 1830.

[3] Florence, 19 September 1839. Richmond MSS.

was well, although Albin Martin had a severe fever during which Dr. William Playfair put sixteen leeches behind his ears before he convalesced, during which time Hannah looked after him. At the end of October, just as they were preparing to leave for home, having despaired of ever getting permission to make copies in the Pitti Palace or the Uffizi, they received a permit, and Hannah had time to copy the Michelangelo 'Doni Madonna'.

Palmer also mentioned Raphael's small picture, the 'Vision of Ezekiel' in the Pitti Palace. Once again it is the Christian mixed with the neo-platonist background to Raphael's thought which strikes him. The Almighty with uplifted arms is making a sweeping descent supported by the Four Beasts.[1] Below, the earth is rent by thunderstorms and rain through which a dramatic shaft of light breaks.[2] Although supported by youthful angels, the Almighty is, in Vasari's words, 'a uso di Giove', and indeed he has a pagan fierceness. Meanwhile in the Chiòstro de' morti in SS. Annunziata, Hannah also endeavoured to make a copy of Andrea del Sarto's 'Madonna del Sacco' fresco. She must have found it difficult to reproduce the particular illusionistic light of this fresco in its lunette, which seems almost to depend on the diffused sunlight of the Chiòstro. The blue highlights, the lilac shadows in the Virgin's white shawl and the exuberant painting of the draperies all appealed to Palmer, as, by tradition, they had to Titian.

Their adventures *en route* for home are almost an anticlimax, being briefly related either because they had become hardened travellers or because they did not wish to alarm Mrs. Linnell; but more likely because they would arrive at the same time as their letters. During the course of the journey, travelling about thirty-five miles a day, they crossed the flooded river Po with their carriage on a raft, were attacked by a man demanding money and armed with a knife, and Samuel was nearly run over in the snow of the Mt. Cenis Pass when the carriage broke a wheel. The journey from Lyons to Paris, taking four or five days 'without going to bed', necessitated a rest in Paris, after which they crossed from Calais to London, arriving at Porchester Terrace at the end of November.

[1] Ezekiel 1: 4.
[2] '*Venir con vento, con nube e con igne.*' *Purgatorio*, XXIX, l. 103.

'Farewell happy fields where joy for ever dwells. Hail railroads!' wrote Palmer.

Yet the Italian story does not end with their arrival in London, for it is part of a very relevant and unbroken thread in Palmer's development as an artist. After a period in which he tried painting in oils without success, he became a member of the Royal Society of Painters in Water Colours in 1854, showing for many years at their exhibitions as well as at the Royal Academy. Many of these drawings are of Italian subjects, and, on the whole, have been underrated; but his real achievement began when he started to etch in copper, that 'teasing, temper-trying, yet fascinating art', as he called it. While John Linnell was as successful in selling his landscape paintings as George Richmond was his portraits, both amassing considerable fortunes, as a result of the art boom in the 1860s, Hannah and Samuel lived simply in London and Surrey, while he eked out a living by teaching. From 1850 until his death in 1881 he produced only thirteen etchings, but they are some of the most exquisite work of their kind, and are the result of his passionate and detailed reading of Virgil and Milton, whose works he carried in pocket editions, and by whom he was so stimulated.

'Much as I love my calling,' he had written to his friend, Dr. Williams from Rome, 'I am a true book-worm, and hope on my return to find about once a month, a whole day for a Great Read.' And in later years it was Virgil's *Eclogues* which he started to translate, and the early poems of Milton in which he was most absorbed, while he practised his skill in etching.

He himself felt a common treatment in observation between his early drawings of the oak trunks at Lullingstone, his cypresses at Tivoli, and the poplars of his etchings. Indeed, these last works have a richness like brush-work, although made by the burin and tint-tool; and they never show the clichéd structural lines used by some of his Victorian contemporaries. Skilful and laborious retouching and stopping-out by Palmer, later, biting in only a weak acid, suggest the details of vegetation or show reflected light on the vault of a cloud. Unlike the works of some 'professional' etchers, Palmer's works, if well printed, have a luminousness even in dark shades, certainly never obtained in mezzotint, and better than wood-

engraving, which often lacks variety in dark. In his early plates, such as 'The Skylark', the white paper glows even in the graded half-tones of the shadows, and the 'little luminous eyes' seem to be warm with colour, though he is spared what he called 'the death-grapple with colour.' His fascination for twilight, or the after-glow of sunset, is still used as a transcendental force which floods gently over the pastoral peace of these etchings. The ploughman, working early, and the herdsman, returning with his bullocks under the rising moon, are directly inspired by Virgil. But let us not mistake the meaning of these idyllic settings. To Palmer, *The Georgics* taught the wisdom of all life, and the mysteries of intellectual discipline under the cover of crops, vintages, cattle, bees, and estate management. This was not an Innisfree where 'peace comes dropping slow' to a lone cabin-builder and bean-grower. Although Palmer, like Wordsworth, did have a vision of the countryside when he was immured in the town, his vision was full of practical activities. And these are equally evident in some of Blake's wood-engravings for *The Pastorals*, which Palmer, in 1872, still thought so 'utterly unique' he would have asked Blake to make headpieces for each of his own translations of Virgil which he was then working on. 'Opening the Fold' from the *Sixth Eclogue*, and Palmer's only finished plate from the drawings of the series, shows the essential work of the shepherd, yet poetically set with the enchantment of distant mountains, romantic, aspiring cypresses, and sky at dawn—an Italian scene round which the eye is magically carried.

> And folded flocks were loose to browse anew
> O'er mountain thyme or trefoil wet with dew.

This is not the decayed arcadia of the later Calvert paintings and engravings, where stylized nymphs or dryads assume classical postures in rural settings.[1] The dilettante paganism of Calvert is far removed from the Blakean idealism of Palmer, in which the imaginative approach to God is through beauty and love; that Renaissance belief felt by Palmer as much as Milton, who also found in Italy his spiritual home. 'Smooth-sliding Mincius', from *The Eclogues*, winds gently in the background of Giorgione's 'Concert

[1] So different from his glorious early wood-engravings.

'Champêtre', and is invoked in 'Lycidas' at the moment when the music of the shepherd's pipe changes from the pastoral to the 'higher mood' of Christian thought. But just as the pagan shepherd was both a pastoral poet and the Good Shepherd, so Palmer's thought in the train of Milton was founded on this dualism.

In writing to L. R. Valpy, who feared the current influences of Victorian materialism, Palmer told him he could not be tainted by the times if he 'loved Milton and did not *hate* Blake'. Palmer himself was never tainted, so grew that manifestation of spiritual force found by Rossetti in Palmer's work, and which he thought had never 'been united with native landscape-power in the same degree'. Even when Palmer had abandoned his 'glorious colouring' for the practice of etching, 'the same unity of soul and sense appears again'.[1] Above all, it is the visual realization of the light-imagery in Milton, especially in 'L'Allegro' and 'Il Penseroso' which Palmer achieved. Indeed, the light and shade imagery play such a part in these poems that they become the symbolism that leads us to the core of the idea conveyed: the cheerful man's dawn compared with the pensive man's evening; the mirth of the 'gay motes that people the Sun Beams' compared with Melancholy born 'of blackest midnight'. But 'Il Penseroso' does not take place at night any more than 'L'Allegro' is in bright daylight. In both poems the action really takes place in those half-lights so beloved by Palmer. Though in this the Virgilian activities of the ploughman, the shepherd, and the mower seem one step removed, not in sunlight, but as in Palmer's poetic and enchanted etchings.

Of Palmer's eight drawings for the Milton series only two were etched: 'The Bellman' and 'The Lonely Tower' from 'Il Penseroso'.[2] The first, printed superbly on a private press by A. H. Palmer, was 'a dream of that genuine village' (Shoreham) where Palmer 'mused away some of his best years designing what nobody would care for and contracting, among good books, a fastidious and unpopular taste'.[3] Assisting his father to print in a way that no professional printer was able, and making these etchings so perfect, A. H. Palmer

[1] D. G. Rossetti, *Collected Works*, Vol. II, London, 1886, p. 504.

[2] Ironically the series was made possible by Linnell's monetary settlement on each of his daughters.

[3] To Mr. P. G. Hamerton, Redhill, 4 August 1879.

nevertheless described his father's life as a 'dreadful tragedy'. One must conclude he was comparing it with John Linnell's worldly success, or Richmond's social brilliance, for no life with a consistent achievement such as Palmer's could be termed tragic.

Palmer himself was too like Milton's Platonist to be tragic.

> Or let my lamp at midnight hour,
> Be seen in some high lonely Tow'r . . .

When he was working on this etching. Palmer wrote again to L. R. Valpy:

You ask me to show you anything which especially affects my inner sympathies. Now only three days have passed since I did begin the meditation of a subject which for twenty years has affected my sympathies with sevenfold inwardness, though now for the first time I seem to feel, in some sort, the power of realizing it. It is from what Edmund Burke thought the finest poem in the English language. The passage includes 'the bellman's drowsy charm'. I never artistically knew such a sacred delight as when endeavouring, in all humility, to realize, after a sort, the imagery of Milton.

The scene (Plate 20) is reminiscent of the Abruzzi: the deep gorge, the bullocks, the semi-tropical vegetation, and the clear star-lit sky.[1] Although it is night, it is not dark, for the moon and the stars shine brightly, while the Platonist's lamp illuminates the tower window, as he investigates Hermes Trismegistus. Palmer has illustrated the imagery and symbolism of 'Il Penseroso' very carefully. The tower, 'on a plat of rising ground', is not isolated, but is near human habitation, the roof and gable of a near-by cottage being visible on the skyline. It is a summer's night when the moon will soon be 'riding neer her highest noon'. The bellman, his figure lit by the light of the waxing moon, can be seen wending his way up the road to the village, as he rings his curfew 'to bless the doors'. He appears exactly as in a previous etching of Palmer's entitled 'The Bellman': an upright figure, bell in hand, having a dreamlike quality as he rings through the night. Further down the road, labourers are returning late from their work to the village; two are resting exhausted in the covered wagon, another guides the oxen

[1] However, it was inspired by the tower and scenery at Lee Abbey, Linton, Devon.

up the hill. All are turned away from the tower, whose light they do not notice or cannot see. Indeed, this light is no concern of theirs, for they have their own light. The 'bellman's drowsy charm' and the distant sounds of the labourers returning—perhaps their songs or the creak of the wagon wheels in the still night, can be heard by *il penseroso* as he 'unsphears' the spirit of Plato.

In the foreground, on the other side of the impassable chasm, are two shepherds, the one lying full-length with his hands cupped under his chin, gazing fixedly at the light in the tower, the other relaxedly sitting and looking at the moon-rise. Their day's work is completed, their sheep being compactly settled under the trees into a peaceful group in which they sleep. Above the tower, in the clear sky, can be seen the constellations of Ursa Major—the Bear, which the Platonist often 'outwatches'—and Casseopeia, that 'starr'd Ethiope Queen' as Milton describes her, born of brightness. Through the harmony of these stars, the shepherds can perhaps hear the music of the spheres, with its Platonic overtones of the souls of the departed spirits, some of whose cromlechs can be seen clearly silhouetted on the distant skyline. Like those more famous 'shepherds on the lawn. Or ere the point of dawn', who heard the Christian divine message, they may be illuminated by the light of the inward eye. Or perhaps they may be hearing only the Lydian airs of Greek tragedy, that music sung by Orpheus, which

> Drew iron tears down Pluto's cheek
> And made Hell grant what love did seek.

For the deep and black chasm may well be the entrance to the under-world taken by Eurydice.[1] But as the shepherds gaze, an owl, Athene's bird of wisdom, flies towards them from the direction of the tower. It is a moment of ecstatic vision for them; one of those rare moments when the music of the spheres can be heard by mortal ears. Palmer and, of course, Milton knew the passage in Plato's *Republic*, Book X, in which the myth of Er is related: how those journeying as souls to the world beyond discerned from above heaven and earth a straight light like a pillar, from whose extremities the adamantine shaft of the spindle of Necessity revolved, with the

[1] Related at the end of Virgil's *Georgics*.

great whorls attached. And on the edge of each whorl, on the rim of
the circles, stood a Siren and from 'all eight there was the concord
of a single harmony'.

So, in Palmer's etching, the two figures on the right may well be
the Genius of the Wood, after his duties are over, with a shepherd,
as in Milton's 'Arcades', one of Palmer's favourite poems.

> To the celestial *Sirens* harmony
> That sit upon the nine enfolded *Spheares*,
> And sing to those that hold the vital shears,
> And turn the adamantine spindle round,
> On which the fate of gods and men is wound.
> Such sweet compulsion doth in *music* ly,
> To lull the daughters of *Necessity*,
> And keep unsteddy Nature to her law,
> And the low world in measur'd motion draw
> After the heavenly time, which none can hear
> Of human mould with gross unpurged ear,

The 'lonely light that Samuel Palmer engraved' was rightly
estimated by Yeats as 'An image of mysterious wisdom won by
toil'.[1] While over all hangs that same moon which lit the Darenth
valley at Shoreham or the Nar below Papigno; that same pastoral
landscape which, like Blake's land of Beulah, brought spiritual peace.
But as at the end of 'Il Penseroso' Milton transposes the Genius of
the Wood into Christian sentiment by

> . . . storied Windows richly dight
> Casting a dimm religious light,

when the pealing organ, the full-voiced choir dissolved *il penseroso*
into ecstasies, and brought 'all Heav'n' before his eyes, so this is the
core of Palmer's thought—the Christian superseding the pagan.
For him, accompanied by his devoted Hannah, the Italian honey-
moon was a vision of 'all Heav'n' which he constantly expressed in
his idyllic landscapes.

[1] W. B. Yeats, 'The Phases of the Moon', *Collected Poems*, p 184. London, 1938.

Bibliography

Alexander, R. G., *A Catalogue of the Etchings of Samuel Palmer*, Publication No. 16 of the Print Collector's Club, 1937.

Beecheno, F. R., *E. T. Daniell. A Memoir*, Norwich, 1889.

Bell, John, *Observations on Italy*, London, 1825.

Bevan, E., *Symbolism and Belief*, London, 1938.

Binyon, Laurence, *The Followers of William Blake . . . S. Palmer*, etc., London, 1925.

Blessington, Marguerite, Countess of, *Idler in Italy: the Journal of a Tour*, London, 1839.

Blunt, Sir Anthony, *The Art of William Blake*, London, 1959.

Bray, Mrs., *Life of Thomas Stothard*, London, 1851.

Brockedon, William, *Passes of the Alps*, London, 1828.

Roadbook from Rome to Naples, London, 1835.

Calvert, Samuel, *A Memorial of Edward Calvert*, London, 1893.

Cennini, Cennino, *Il libro dell'Arte*, ed. Daniel V. Thompson, jun., Yale, 1932.

Collins, William Wilkie, *Memoirs of the Life of William Collins, Esq., R.A.*, London, 1848.

Cox, David, *A Treatise on Landscape Painting*, London, 1848.

Coxhead, A C., *Thomas Stothard, R.A.*, London, 1909.

Cunningham, Alan, *Life of David Wilkie*, London, 1843.

The Lives of the most eminent Painters . . ., etc., London, 1832.

Dickens, Charles, *Pictures from Italy*, London, 1846.

Dwight, Theodore, *Journal of a Tour in Italy in the Year 1821 . . .*, New York, 1824.

Eastlake, Lady, *Life of John Gibson, R.A., Sculptor*, London, 1870.

Eaton, Charlotte, *Rome in the Nineteenth Century*, London, 1820.

Eustace, the Rev. John Chetwode, *A Classical Tour of Italy in MDCCCII*, London, 1815.

Finch, Eliza, *Memorials of Francis Oliver Finch by his widow*, London, 1865.

Freeman, James E., *Gatherings from an artist's portfolio*, New York, 1877.

Friedlander, Ludwig, *Views in Italy in the Years 1815 & 1816*, London, 1821.

Forsyth, Joseph, *Remarks on Antiquities, Arts and Letters in Italy in the Years 1802 and 1818*, Boston, 1818.

Gernsheim, Helmut and Alison, *L. J. M. Daguerre*, London, 1956.

Gilchrist, Alexander, *Life of William Blake*, London, 1863.

Giles, William, *Guide to Domestic Happiness*, London, 1805.

The Refuge, London, 1810.

Graham, Maria (Lady Callcott), *Three months passed in the Mountains east of Rome. 1821*, London, 1821.

Grigson, Geoffrey, *Samuel Palmer. The Visionary Years*, London, 1947.

Hardie, Martin, *Samuel Palmer. A Lecture to the Print Collectors' Club. 16 November, 1927*, London, 1928.

Harding, J. D., *The Tourist in Italy. Landscape Annual*, London, 1831.

Hart, Solomon A. (ed.), Alexander Brodie, *Reminiscences*, London, 1882.

Hawthorne, Nathaniel, *The Marble Faun*, Boston, 1860.

Hazlitt, William, *The Examiner*, London, 1816.

Ibbetson, Julius C., *An accidence, or gamut, of Painting in oil and watercolours*, London, 1803.

James, Henry, *Italian Hours*, London, 1909.

Keynes, Geoffrey, *Blake Studies*, London, 1949.

Leslie, C. R., *Memoirs of Constable*, London, 1951.

Longfellow, Henry W., *Outre-Mer*, London, 1835.

Rome in Midsummer, London, 1828.

Lear, Edward, *Views of Rome and its Environs*, London, 1841.

Linnell, John, *The Royal Gallery of Pictures . . .*, London, 1840.

Lister, Raymond, *Edward Calvert*, London, 1962.

Matthews, T. (ed.), *Biography of John Gibson*, London, 1911.

Murray, John, *Handbook for Central Italy*, London, 1843.

Palmer, A. H., *The Life and Letters of Samuel Palmer*, London, 1892.

Samuel Palmer. A Memoir, London, 1882.

Palmer, Samuel, *A lecture*, etc., 1928. Print Collector's Club Publication.

An English Version of the Eclogues of Virgil, London, 1883.

The Shorter Poems of John Milton, London, 1889.

Pater, Walter, *The Renaissance. The School of Giorgione*, London, 1888.

Porphyry, tr. Thomas Taylor, *On the Cave of the Nymphs . . .*, London, 1917.

Procter, A. A., *Samuel Palmer. Legends and Lyrics*, London, 1866.

Reynolds, Graham, *Painters of the Victorian Scene*, London, 1953.

Reynolds, Sir Joshua, *Discourses*, London, 1837.

Redgrave, Richard and Samuel, *A Century of Painters of the English School . . .*, London, 1890.

Redgrave, F. M., *Richard Redgrave. A Memoir*, London, 1891.

Reitlinger, Gerald, *The Economics of Taste*, Volume 1, London, 1861.

Robinson, Henry Crabb, ed. Derek Hudson, *Extracts from the Diary of . . .*, London, 1967.

Rogers, Samuel, *Italy, a poem*, London, 1822–8.

Roget, John Lewis, *A History of the Old Watercolour Society* . . ., London, 1891.

Ruskin, John, *Modern Painters* . . ., London, 1843.

Richmond Papers, ed. A. M. W. Stirling, London, 1930.

Smetham, James, *Letters*, London, 1871.

Starke, Mrs. Mariana, *Letters from Italy*, London, 1800.

Stephens, F. G., *Notes on a collection of drawings, paintings, and etchings by* . . . *S. Palmer*, London, 1881.

Storey, William W., *Roba di Roma*, London, 1862.

Story, A. T., *Life of John Linnell*, London, 1894.

Thackeray, William, *Fraser's Magazine, 1840*.

Uwins, Mrs. (ed.), *A Memoir of Thomas Uwins, R.A.*, London, 1858.

Index